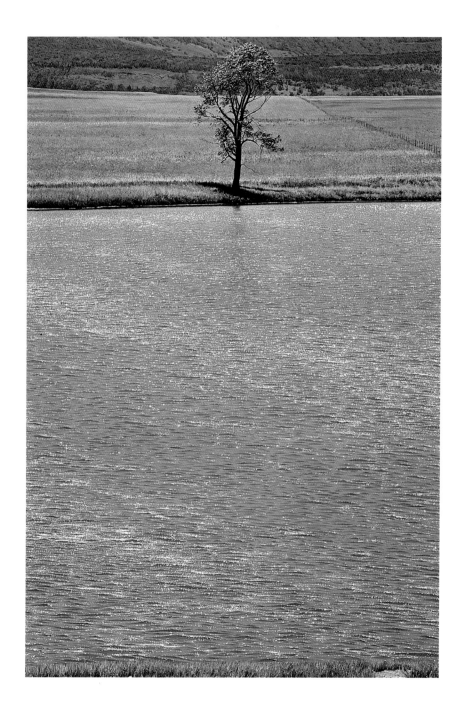

W O O D Y

G W Y N

PETER SACKS

INTRODUCTION BY SHARYN R. UDALL

TEXAS TECH UNIVERSITY PRESS

This book was set in Garamond and Copperplate Gothic and printed on acid-free
paper that meets the guidelines for permanence and durability of the Committee
on Production Guidelines for Book Longevity of the Council on Library Resources.

Design by Steve Renick

Printed in Hong Kong

Library of Congress Cataloging-in-Publication Data
Sacks, Peter M.
 Woody Gwyn / text by Peter Sacks.
 p. cm.
 Includes index.
 ISBN 0-89672-344-5 (cloth)
 1. Gwyn, Woody, 1944- —Criticism and interpretation. 2. Gwyn, Woody,
1944- —Catalogs. I. Gwyn, Woody, 1944- . II. Title. III. Title: Gwyn.
 ND1351.6.S33 1995 94-36852
759. 13—dc20 CIP

95 96 97 98 99 00 01 02 03 / 9 8 7 6 5 4 3 2 1

Texas Tech University Press
Lubbock, Texas 79409-1037 USA
1-800-832-4042

My parents,
Donovan and Estrelda,
despite all their difficulties,
did everything they could
to help me become what they
both believed was a special thing:
an artist.
This book is dedicated
to their memory.

Acknowledgments

I remember hearing once that it takes about a thousand people to make one self-made person. Just about the same can be said for this book.

I have a feeling that my friend of long-standing, Paul Milosovich, had a lot to do with the initial idea for this project. Thanks, Paul.

From the very beginning, Judith Keeling's interest and belief have remained constant. Along with everyone else at Texas Tech University Press, her encouragement and enthusiasm have been wonderful.

I thank Norma and Ervin Baumann, Milton Butcher, and Mr. and Mrs. Lindsay B. Holt of Architectural Products, Inc., El Paso, for their support.

My appreciation to Sharyn Udall, Peter Sacks, and Mark Stevens for their insight, professionalism, and patience.

Much gratitude to my wife, Dianna, who has helped me in more ways than I can say.

Contents

WOODY GWYN

Landscape Painting and the Social Meaning of the Earth

SHARYN R. UDALL

Landscape, seen through human eyes, is never neutral. But it has taken a long time for people to realize that landscape and landscape painting carry cultural messages reaching to the heart of the human experience.

Take roads, for instance. Trails, paths, and highways are more than evidence of human activity. They are marks of social meaning impressed into the earth, inscriptions of cultures that made and used them. Stretched along their distance are assurances of direction and meaning that reflect changing ideas about the land.

Certain ancient roads, like the Appian Way, the medieval pilgrimage routes, or the Silk Roads connecting Europe and Asia, have carried much of the world's known history over their lengths. Others, such as the great Anasazi network leading into and out of Chaco Canyon, remain mysterious. Long abandoned to the eroding effects of water, wind, and time, the fragile road traces at Chaco nonetheless still testify to careful sky and surface orientations. They suggest slow passages, at a walker's pace, through states of mind and ancient cycles of seasons, perhaps between realms of the living and dead. Though their cosmic secrets are mostly lost to modern observers, we know these Chaco roads were once of profound ceremonial and symbolic significance.

Not all southwestern roads have trafficked in such exalted collective meanings. Most, old or new, are paths from here to there—links between countless points of origin and destination. Glinting under wide expanses of open sky, these ribbons of passage testify to human visitation in the always encroaching emptiness. For in parts of the West, it is still the void that defines the landscape and defies artists to capture it.

Generations have taken up the challenge. Along with writers, poets, and photographers, landscape painters have struggled to image the changing American West—no mean task in places whose character resides in an elusive, pristine otherness. Awestruck, early beholders recorded the West's roadless sweep of earth and sky, observed but as yet unchanged by humanity (fig. 1).

But the primeval emptiness soon gave way to the axe and the wagon wheel, etching traces of relentless westward movement. Nineteenth-century American landscape paintings often became visual demonstrations: here is what progress looks like. Here are the resources of the West, ready to serve the needs of its settlers (fig. 2). Until recently, when revisionist views of nineteenth-century American landscape painting have made us question its subtly disguised political and social biases, the interaction of humanity and the landscape was seen as a salutary, inevitable "taming" of nature's chaos.[1]

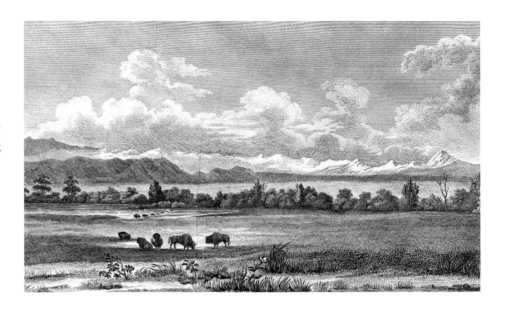

Each generation learns to see landscape according to a socially constructed set of ideas. Such paradigms are, of course, the product of complex historical forces. Renaissance humanism and the evolution of scientific method, for example, are two factors of profound importance in shaping the Euro-American view of landscape in the past five hundred years. From Van Eyck's tiny glimpses of landscape seen through open windows, to Piero's often-tyrannical one-point perspective, to Poussin's carefully orchestrated recessional planes, we can follow a single implicit assumption: that landscape is there to be seen and ordered by human will. As soon as a human gaze rests upon a patch of land, it becomes an object of which we (or specifically, the artist) become the acting subject. The power of eye and hand transforms landscape into a social product.

In American painting, these assumptions are visible in a 1915 painting by Taos artist Oscar Berninghaus, *A Showery Day, Grand Canyon* (fig. 3). Both artist and patron (the Santa Fe Railway) were keenly aware of the tourist potential of the canyon and were eager to lure visitors to the Southwest. Even as this painting celebrates the accessibility of natural wonders, it speaks, in a subtler way, about nature as public theatre. Stretched out before a group of foreground visitors,

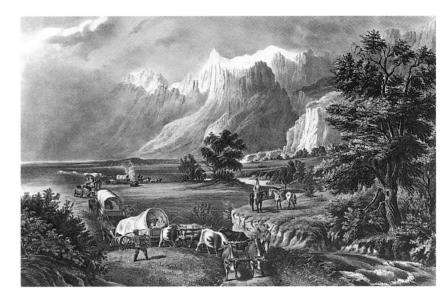

FIGURE 2

Fanny Palmer, *The Rocky Mountains, Emigrants Crossing the Plains,* 1866, lithograph, 17 ¹/₂ x 25 ³/₄ in. Amon Carter Museum, Fort Worth.

the chasm is a grand visual spectacle, a performance complete with dramatic effects of clouds and rain. Incorporated by our own act of looking, we join the other spectators behind a retaining wall that defines and separates human-constructed space from the wildness of the canyon. Nature here is the sublime, ineffable, calculated *other.*

Every age finds the paintings it needs. Woody Gwyn's painting helps us to understand that the external world is always mediated through subjective human experience. When he paints an isolated stretch of highway, a stand of trees, or, for that matter, the Grand Canyon, he opens an inquiry that involves more than earth, sky, and vegetation. His is a visual dialogue between the acute specificities of the present moment and the cumulative weight of historical vision.

Woody Gwyn's painting of the canyon, (*Tourists,* 1988-89), rare in his oeuvre for its inclusion of figures, offers a telling contrast to that of Berninghaus. Gwyn's canyon visitors press in laterally—engaging the view, merging with the experience rather than standing apart from it. For them and for us, the subject-object dichotomy breaks down; apartness gives way to interaction with nature. In a certain sense, this painting summarizes one of the major themes in Gwyn's painting: a new kind of artistic encounter with nature. New because it dispenses with the landscapist's traditional props for evoking

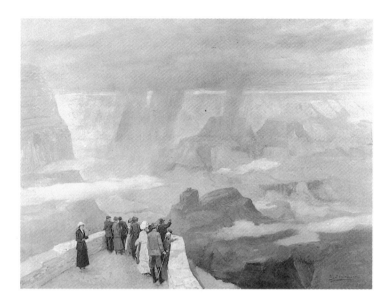

human associations: nostalgia, sentimentality, and the merely picturesque. In their place Gwyn has set up a model of reality born of, but not imprisoned by, the received visible world. Free to roam within his landscape of materialized essences, Gwyn plays thoughtfully with formal questions—moods of line, textures of surfaces, subtle harmonies of color—that engage him repeatedly.

When choosing the canvas size, for example, he thinks carefully about the perceptual experience his paintings will initiate. And when he returns to a subject a second or third time, it is often to establish a larger scale and therefore a new range of experience for the viewer. But even when Gwyn's paintings stretch to a length of twelve or fourteen feet, they never overwhelm the viewer with sheer size as, for example, a thundering Bierstadt or a monumental Church landscape often can.

Apart from his sensitivity to questions of scale and the power of sight, Gwyn's painting resonates with an understanding of a second, more obvious way that landscape is socially constructed: in the twentieth century our visual surroundings

are almost always the product of human transformations of nature. A road bisecting an open expanse is an obvious example of this. So are highway interchanges, bridges, and parking lots.

What are we to make of Gwyn's fragments of humanized earth? As with much good painting, the initial pleasure of looking gradually gives way to rich, unexpected complexities. These paintings are, in fact, full of tension and paradox. At once timeless and utterly contemporary, they visibly contradict the pace of the twentieth century, this era of speeded-up perception, minutes crowded with visual incident, and quickly forgotten optical layering.

We feel the inexorable tension between highways built for speed and painting that demands slow, deliberate looking; between knowing that the center of things is elsewhere and Gwyn's insistence that it is palpably here, now, on this stretch of road; between a silent space devoid of human trespass and the sure knowledge that a blur of hurtling metal will soon whine past, impatient to devour unseen distances. For these are paintings about the implications of the beyond, about arbitrary completion and deliberate incompletion. Always, Gwyn paints less than he knows.

These landscapes, studied slowly, invite us to consider anew the absences and presences within the land. Though tinged often with alienation, melancholy, or loss, Gwyn's subjects press quietly beyond what they describe. Like the roadcuts his brush interrogates, they slice into the western landscape with an acute visual clarity. And like some of Georgia O'Keeffe's work (which he admires), they cut swiftly to the heart of a tangle of myths flung over the West, a network as ineradicable as its web of old and new roads. We could travel endlessly within this system, whose interchanges in steel and concrete mimic (in a kind of latter-day Platonic scheme) the impossibly delicate brain synapses where visual and cultural meaning connect.

Like the earth's surface, each mind has its own topography; Woody Gwyn's is open, fluid, expansive, like his canvases. Disguised in the persuasive truth-telling of realism, his paintings invite us to explore realms where nature and culture (long and perhaps falsely dichotomized) test mysterious new affinities.

ENDNOTE

1. See, for example, the essays in *The West as America: Reinterpreting Images of the Frontier, 1820-1920,* ed. William H. Truettner (Washington: National Museum of American Art, 1991), and in Jules David Prown et al., *Discovered Lands, Invented Pasts: Transforming Visions of the American West* (New Haven and London: Yale University Press, 1992).

WOODY GWYN

AN APPROACH TO THE LANDSCAPE

The Paintings of Woody Gwyn

PETER SACKS

It was an odd road to be walking, this of painting. Out and out one went, further and further, until at last one seemed to be on a narrow plank, perfectly alone, over the sea.

VIRGINIA WOOLF, *To the Lighthouse*

Gwyn reflects on his future plans and notes that Emerson once said, "Every cubic inch of the universe is a miracle." He muses, "Wouldn't it be wonderful to be able to paint that way?"

M. J. VAN DEVENTER

The subjects of Woody Gwyn's art always appear to be so immediately identifiable, so unambiguous, so resolutely *manifest,* that they at first seem to need no commentary or interpretation. In fact, much of his work's initial appeal is the astonishing clarity and confidence with which it puts forward its world of well-lit, sharply defined landscapes. For such clarity and confidence are infectious, and the viewer is brightened by the exhilarating certainty with which *Road Cut, Black Mesa, Guardrail, Highway/Ocean, Palm,* to name a few typically substantive titles, give themselves up for viewing. Until we come to recognize the real mystery within these paintings, their first hold on us is thus perhaps the initial absence of mystery itself, the declarative sense that A = A, not B, C, or Z. This exactly rendered *Road Curve* is a road curve: no perceptual peering or reconstructing required, no deciphering of occult allegory or metaphor, no translation.

And yet, Woody Gwyn's paintings do have an intense metaphorical life. Far from being photo-realist reports, these precise renderings are also subjective meditations and expressions. Each portrayal points toward otherwise unseen meanings or states of being. Ultimately, the most remarkable feature of the work is its *simultaneous* existence on literal and metaphorical levels. Without losing a shred of physicality or exactitude, without releasing us from the fascination of what's here, and above all without compromising his vigilant fidelity to the given world, Gwyn also conjures an urgent metaphysical presence that makes his work that rarest of sites—a meeting ground of realism and spirituality. In his own words, the aim of "all art, whether it is abstract or realistic . . . is to bring us to the same state of mind: to transcendence and the essence of things."[1]

Since it is the copresence of fact and metaphor, of ground and evocation, that I will be addressing here, I should admit right away that the metaphorical or poetic element of these paintings cannot be specified with the same kind of objective confidence with which we say *road curve* or *palm.* What we make of that curving road or that tree is a speculative undertaking to which Gwyn invites us, a journey whose solitary nature is signaled and reinforced by the stark, unpeopled reaches of these scenes and by the way each painting explicitly stresses its distinctive point of view. Much of this essay therefore is only one such set of responses, offered with the kind of freedom and expansiveness that I think the literal stretches of highway and wide open spaces in these pictures are in part designed to elicit and savor. If Gwyn's work both embodies and represents a kind of journey, the meaning of that journey is finally constructed by all who travel its reaches; and here the painter himself is only one such traveler. The fact that he scrupulously refuses to preempt the more than

literal significances en route, and that he refrains from guiding or nudging us too closely toward certain conclusions, in large part accounts for the clean, unbiased openness of each painting, its scoured freshness, and its radically democratic spirit. This too—as much as the actual southwestern light—accounts for just one of the sources or meanings of the high-powered clarity that illuminates each scene. Other aspects of the spaciousness, the light, and the more material contents of these landscapes await us along the way.

To return to the literal level of Gwyn's realism, the apparent matter-of-factness and frank self-sufficiency of his subjects would seem to belong to one of the strongest currents in American culture, the celebration of a reality that is starkly presented as being nothing other than itself. "No ideas but in things"—especially things of a new world, which could not be truly apprehended by old-world habits of perceiving, naming, and thus imposing meaning. This challenge would be exaggeratedly so for landscape paintings that sought to capture the raw novelty of an as yet incompletely colonized and cultivated territory. And as the Europeans moved westward, becoming the new Americans, so the region of surviving rawness was pushed back with them, until little remained untouched apart from certain stretches of scarcely habitable land that they left unmarked except by the signs of their passage: wagon tracks, railroad lines, highways. It is this territory and its most recent signs of passage that Gwyn has most often chosen to paint, and we shall see how his work recapitulates yet complicates and even offers to reroute the history of his art, his culture, and his land.

A starting point for responding to Gwyn's work is to clear the mind of all presuppositions, all foreknowledge, all prejudice, and to let the eyes take in what is immediately before them. The paintings encourage this act of clearing out by the startling, even shocking, clarity of their light, and by the fact that so many of them present cleared-out expanses of roadway or land. Look at *Interstate Guardrail* (1983-84) and see what you've never seen with such luminous precision: the grain in the segmented chocks of wood supporting the highway barrier; the rivets and grooves in the bending metal; the searing sheen where the rail slopes back to reflect the sky; the similar, nearly incandescent sheen that coats the tops of pebbles along the shoulder of the road; the tawny wisps of wildgrass that penetrate the uneven asphalt margin; the play of seam and crust in the exposed flank of the hillside where the road was blasted through rock; the concentrated brightening of the sky where it rims the darkly treed crests of land or where it blends into the furthest, vanishing surface of the road.

To see these things is to see (and feel) much more as well, but we'll come to that a little later. For the moment, just to register the visual information of Gwyn's paintings, their brilliant specificity and overall impact, is to register a great deal.

What is it, then, that invites us to see still more within these already generously exposed works? When so much is laid out before us in such detail and in such a candid light, what prompts us to look or think still further into the scene? When the contents of the painting are displayed with such an impartial distribution of high focus as to prevent one element from dominating another, why should we want to select some object or theme for special attention? And with such an abundance of fact, why reach for interpretation or metaphor—particularly when the facts in question seem to be so free from either the inflections of personal mood or the freight of old iconography? This kind of question is hard to answer without relying upon something like intuition. And to acknowledge this is to recognize one of the crucial forces of Gwyn's work: its reliance upon intuition, and its careful fostering of that reliance. As he has said, "I think my work has to do with intuition. . . . I don't think my work is about how the photograph sees reality. I'm creating an object, I hope, of my own vision."[2] But for the viewer, what *is* the intuition that keeps us investigating or brooding on the work? Or, to start at a more basic level, what does that intuition feel like? The simplest answer would be that the intuition is whatever keeps holding us in front of the painting long after we have seen what is there: we remain arrested, in the grip of something more than visual information. This arrest is all the more powerful because so many of these paintings—particularly those of highways—are themselves partly about the tension between high-speed travel (and high-speed viewing) and intense stillness. The paintings hold us with the kind of force that can stop a speeding traveler in his or her tracks. And they maintain their grip on us because they themselves are so thoroughly in the grip of that arresting force. As Gwyn describes his way of finding new subjects: he drives along the road "until something hits me."[3] His paintings are not simply about what he sees, but rather about the collision itself. The impact's shock waves (one of many kinds of waves in Gwyn's work) keep vibrating through his response, from first sketch to finished canvas. In fact, Gwyn's sketches are a crucial element of his overall work; one aspect of their importance is their recording the instantaneous gesture with which a subject first struck the artist—the moment at which one can hardly tell who is apprehending whom. Much of Gwyn's achievement occurs right here, although it is followed by the remarkable feat of preserving and enhancing that first gesture or grip into a larger, more highly resolved format. If the small sketch preserves the immediacy and bodily involvement (not just of

the eye, but of the hand—the first grip of acquaintance, or "handshake" with the view), the technical challenge of the more formal larger work is to extend and elaborate that involvement without losing touch.

It would be impossible to name all the visual elements that both "hit" and hold us intuitively in Gwyn's work, that capture the odd compounding of motion and arrest. The most obvious would be the literal manner in which the paintings allow the eye to move very rapidly through their swiftly receding and usually deep spaces, while at the same time maintaining an exceptionally stilled focus and resolution on all things, near and distant. This is exaggerated in the paintings of highways, where the eye actually speeds through or across the painting and yet sees things with the unblurred clarity and near-microscopic scrutiny that require the utmost stillness. We are absolutely stopped, but a powerful momentum continues to move through and beyond us, a kind of lurch or buckling wave. By his way of cropping the view, and frequently of intensifying a torque-like wrench of frontal and angular points of view or of contrary vectors within the scene, Gwyn paints us into an unusually taut set of contrasts that keep us riveted—like that guardrail—rippling onward yet staying in place at the same time. The road careens ahead, the eye zooms through the uniquely clear and unimpeding air (none of the hazy or dense atmospheric weather on which so much European landscape painting depends), and yet everything is halted.

There is something almost violent about this wrenching compound of high speed and absolute stillness, and my sense is that such violence is in fact deeply true to the nature of these highways. On a semihumorous level, it's there in Gwyn's admission, "I've actually had my easel blown off by semis . . . which is discouraging."[4] We can see the violence in that blasted siding of rock, or the shorn-off rippling of the slopes alongside, or the severe contrast of blacktop versus natural dirt or grass. Such evidence suggests other forms of conflict or outright violation: the dislocated lives of many who travel these highways; the force with which a speeding car wrenches us out of our bodily pace, and therefore out of our normal physical relation to place (not to mention the sheer oddness of sitting still while surging across the land at sixty miles an hour); the obvious dangers—and many of Gwyn's paintings include danger signs, as well as guardrails—of highway travel, both for ourselves and for whatever creatures may wander into our path; and the often horrifying role the trails and roadways have played in the conquest and "development" of the land and its people. "Maybe my art is really about man

the plunderer," Gwyn has remarked.[5] I will return to that idea later, but it does take us further into the kinds of shock and trials that dynamize these calm yet concussive works.

A further appeal to our intuitive fascination—our being in the grip of something more than representation—is the charged *surface* of Gwyn's paintings, especially the way in which depicted objects seem to respond to the light. The southwestern light has a clarified and clarifying intensity, and in northern New Mexico this intensity augments a quality of elevation that tends to purify still further whatever it illuminates. But Gwyn's achievement is to show us how his subjects do far more than merely receive this light—rather, they *participate* in it. Whether it's the strangely vibrating surface of the road, the phosphorescent glow of certain foliage, the rhythmically streaked or faceted translucency of water, even the trenchant regions of shadow, every inch is charged and radiant. One intense pitch of this appears in *Mirage II* (1990), where the roadway literally disappears into waves of light; but the motif is implicit in almost every other painting, for there is nothing in Gwyn's world that seems to lack an inner force, a source of wavelike emissions of energy. To respond fully to the visual power of Gwyn's paintings is to intuit the *connection* between this microscopic wave-force and the large-scale oscillations of the road, or guardrail, or undulating land. We thus are immediately caught up in a complex field of force, one that vibrates in such a way as to connect our own currents of perception, intuition, energy, with those of the painting, and thence with the charge of the outside world. By a truly unusual extension and modernization of realism, the art renders the surface appearance of reality while also capturing its living gist—a motion as of waves, which our century of particle physics and nuclear fission has exposed at the heart of light and of all living or inanimate things. Indeed, Gwyn's brilliance reminds us that the word *inanimate* may be inaccurate or relative at best.

At a technical level, Gwyn often secures this interactive radiance by enhanced methods of optical mixing (similar but not identical to Pointillism) and tonal gradation, so that the vibrancy of the perceived color or object is inseparable from the viewer's participation in forming the compounds that make up both that object's visual life and its active relation to what surrounds it. By careful juxtaposition of color, and by minutely contrastive levels of color saturation, Gwyn produces an almost molecular vibration, not unlike that of a TV screen (as he himself suggests), which glows from the inside out. This inner radiance is at the heart of Gwyn's vision, and we begin to see how thoroughly that vision determines not only the surfaces but the deepest and ultimately mystical substance of his subjects and compositions: "I think mysticism is

whenever you're feeling and sensing reality from the inside out. Art is one way of doing that, of sensing reality from the inside out."[6] For the moment we can recognize how the inner vitality of the surface not only unifies the painting (and the perception of unity is a crucial element of mysticism) but also imbues each represented object with the hypnotic compound of motion and stillness. Things stay in place, yet their very mode of existence is one of intensely active vibration—just as we had felt the conjoined presence, both in the content of the paintings and in ourselves, of great velocity and of an oscillating, thrilled arrest.

To its suspension or contrasts of motion, and the dazzling grip and emission of its surfaces, we could add yet another source of the hold Gwyn's work exercises on our intuitions. I'm thinking of the brooding, anticipatory silence that calls on us to wait in front of these paintings, which themselves so often are *about* waiting. (Perhaps it is no coincidence that Gwyn's earlier work focused for some time on hitchhikers.) As he has admitted to M. J. Van Deventer, who has noticed this strong feature of Gwyn's work, "There is something special about the silence that intrigues me. . . . The silence gives me the feeling that something is about to happen . . . a feeling of anticipation."[7] So here is yet another odd mixture of stasis and possible movement, or an incipient drama dwelling in the nature of things—something that keeps us not only attentive but in actual suspense. An urgent temporal dimension enters these otherwise timelessly hovering vistas. To interpret each picture is in large measure to understand the complex nature of this urgency.

Having established this intuitive dimension, we may want to ask what kinds of *meaning* it may reflect and evoke. Granted that there is something "more" here, what could it be? In a way, we have already begun to answer the question by thinking about space, light, silence, contrasts of speed and highly charged arrest, violence, inner radiance, bodily and spiritual apprehension, temporality, mysticism. But we can refer more specifically to the chosen subject matter and its connotations. The best way to approach this may be to follow Gwyn's own "approach to the landscape," namely the highway. By calling the highway an "approach to the landscape,"[8] the artist tells us that his many works that actually include highways are curiously doubled in content—they are about a landscape while also about the very means of approaching the landscape (both in reality and in art). This self-consciousness about approach is obviously a sign of Gwyn's modernity, but it also sharpens the high degree of personal involvement in what might otherwise have been rather

impersonal subjects. Each scene is about itself *and* about the way of approaching it, just as the dramatized point of view is usually abruptly foregrounded to serve as a visual reminder of this matter of approach.

In Gwyn's case, then, the highway is more than an object: it is also a metaphor for an approach, or rather for the phenomenon of approach itself, for a way of seeing and regarding both life and art. In his own words, after painting his first highway in 1973, "I felt like a worm holding onto a twig. Yet, I realized the highway was a conduit . . . a breeder idea. It gave me an *approach* to the landscape."[9] The external motif of the road thus becomes an enabling inner path for the artist's development—and the contrast of inchworm with highway nicely suggests yet another variant of the kind of tension we have already noticed between stillness and high speed, in this case between the painfully slow *inner* progress of an artist's vision and technique and the rapid pace of more public notions or means of progress. My view of this dimension of the highway as metaphor for Gwyn's sense of artistic direction is reinforced by other statements he has made: "I know there will be, someday, the last highway. It's inevitable. Yet, for now, the highways still keep leading me on. And I'm happy that something has gripped my attention for so long."[10] We've already spoken of a gripped and gripping quality; the curious mixture of an arresting grip that is also an onward leading force takes us to the heart of Gwyn's work: "I'm always hoping the idea will take hold of me and lead me in the direction it wants me to go in."[11] At least part of the highway's meaning here is that of a charged compound of means and metaphor, a sign not just of subject matter but also of viewpoint and inspiration itself. For Gwyn, to paint the highway is to paint the shape, the surface, the actual substance and vector of his own career; hence the unusually charged and suspenseful drama infusing every inch of these portraits. Indeed, it would not be absurd to claim that in one respect Gwyn's pictures of highways and landscapes make up a kind of oblique vocational roadmap or self-portrait.

Gwyn's highways are also far more than personal—his real success here has been to wed deeply personal motives and motifs to their public or even national equivalents. But to stay at the personal level for a moment, we can underscore both the metaphorical and the personally talismanic role of the highway for Gwyn by yet another telling remark: "I keep thinking I'm doing my last highway and then I get inspired to do another. I suppose Monet did his lily pads because they gave him an excuse to express the things he was interested in. They became a metaphor for life; I feel the same way about my highways as he did about his lily pads."[12] It's a long way from the gardens of Giverny to the wide open stretches of

southwestern highways (in many ways the distance is that between early-twentieth-century France and late-twentieth-century North America); but for each artist the metaphor is a compellingly repeated expression of himself, of his art, and of life itself.

To claim that the highways are "a metaphor for life" is to recall one of the oldest and most widespread figurative meanings of the road. From scripture and ancient epic literature to *Pilgrim's Progress* (a book that accompanied so many colonists and pioneers), and from Whitman's "Song of the Open Road" to the latest short story, movie, or country-and-western lyric, the road has been one of our nearly universal figures for the journey of life. It is by this figure that Gwyn connects his personal vision and urgency to a larger sphere. While painting an element in the course of his own life, Gwyn is portraying a no less powerful strand in that of his nation. And far beyond this public or national realm, he is painting the journey of human life through the natural world. A large part of these paintings' hold on us derives not simply from their wide public dimension but rather from the fact that Gwyn has found a *nexus* between what is most private and what is so widely shared. We each move down these highways alone (the solitude within Gwyn's work is extreme), but everyone makes some kind of journey; and in more respects than we might have come to trust in recent years, certain stretches of that journey are made collectively.

The collective journey in North America has been the great westward invasion of the land. If the indigenous Americans left traces of their collective journeys in the form of spiral petroglyphs, then certainly one representation of the more recent immigrants' harsh linear trajectory is that of Gwyn's interstates. By painting the contemporary highways, complete with overpasses, medians, guardrails, shoulders, and signs, Gwyn thus alludes not only to the entire enterprise of opening up the land but also to the most recent and continuing form of that enterprise. Often, his highways appear to be quite new: a familiar stretch of road for Gwyn (Interstate 25, which climbs from the Galisteo basin into the lower slopes of the Sangre de Cristo near Santa Fe) was constructed less than thirty years ago; the asphalt in *Parking Lot/Ocean* is so newly laid one can almost smell the tar; and in the most extreme case (*Black Mesa*) Gwyn actually jumped ahead of time by painting a seasoned gray road as if it were new blacktop, only to find reality imitating art a few months later. This contemporaneity is deliberate, a way not only of updating his art's relation to tradition but also of facing the reality of our time, however intrusive or unnatural: "I think an artist should be of his time. Art helps us to deal with reality by

showing us it is not something we should run away from. . . . I hope my work has some of the atmosphere of what is happening right now in terms of the environment."[13]

This last phrase lets us approach Gwyn's work at both obvious and subtle levels. Yes, we have already noticed the harsh clash of roadway and natural landforms that have been blasted, graded, and paved over. And we clearly recognize the central theme of humankind's relation to nature. What makes this more complicated is that Gwyn's paintings recognize both antagonistic *and* what we might call potentially sympathetic elements in this relation. His paintings are not just about the human journey but ultimately about the ways and journeyings of the earth itself. Indeed, this work invites us to alter the course of our human journey by more fully recognizing the ways of the earth and the fact that our travels are ultimately inseparable from the evolving course of the planet.

If this sounds rather abstract, we might look at a few examples. *Rio Grande Bridge* (1983) offers an elevated and far-reaching view over the primordial river valley. As is often the case in Gwyn's work, our vantage point is dramatically foregrounded so that we can never forget or take for granted the threshold between us and what we see. As in *Ocean/Highway, Palm, Black Mesa,* and several others, the highway or asphalt runs at right angles to the view, thereby giving the threshold an exaggerated presence that makes us wonder on what terms we can in fact engage what we encounter beyond. To a certain extent this accurately reflects the way in which *any* view of the world is framed or mediated by some kind of interposition, whether of a material or of a perceptual nature. Here (and most extremely in the *Tourists* works of 1988) the material interposition is starkly imposed in the form of an actual barrier, suggesting that any communion with the natural world will have somehow to cross or surmount all that our civilization has put between us and the land. But the paintings are more canny than this, for the barrier is also protective: any attempt to surmount it would be suicidal. And in *Tourists,* whose shifting preparatory sketches emphasize how much this painting is *about* vantages and points of view, the barrier actually allows spectators to lean out over the canyon. Rather than ignoring or opposing the guardrail (perhaps it is a proxy for the framing devices within all painting, or for the vertical, screenlike nature of painting itself), we may regard it more carefully in such a way as to see what our human creations share with the world around them.

Apart from providing a safe vantage point (although we've not yet crossed the dangerous road to get there), the barrier along the Rio Grande bridge offers certain perceptual cues. The boldly illuminated rods of the railing prompt the eye to

notice similar striations in the view beyond—the vertical fissures in the opposing walls of the canyon, or the diagonal stripes of light and shadow across the slopes. By seeing these we are drawn into the geological and temporal features of the land: the physical formation of the earth's crust, and the shifting submission of all surfaces to the movement of light and darkness that marks the passage of time. Hence the painting offers several different but related types of evolution: the slow eons of geology, the recent technological artifice of humans, the daily journey of light over the revolving planet. All this is made *visible,* and what might have seemed purely formal aesthetic similarities thus act as a visual metaphor for deeper interrelationships. Once we intuit what we and our constructs share with the world at large, even if this shared element is as fundamental as a common participation in the journey of time, perhaps the dislocative transience of our own lives may seem less uniquely commanding, or perhaps we may realize the existence of a greater single life-course of which ours is just a dependent part. Ultimately, then, this deeply perspectival painting is about putting things into more than merely visual perspective.

In speaking of a greater life-course, it is tempting to look down at the Rio Grande and to notice another visual similarity that has a metaphorical load. For the river is another kind of course, here traveling almost exactly at right angles to the highway. Since the river is associated with the life-flow of nature, we may wonder whether our highway (and thereby the human direction of technology and progress) is itself presently at odds with the sources and currents of the natural world. I don't want to push this too far, for Gwyn is too discreet an artist for such simplifications, but it is the kind of associative response that such a painting invites. And if we dwell on this a little longer, we may come to feel that the extreme brevity with which we would otherwise flash across the horizontal highway base of the picture is outweighed by the slow course of the Rio Grande, a course with which we may therefore associate both a different way of looking (a long, meditative gaze versus a speeding side glance) and a different way of traveling. Is it possible that the far-off bend in the river acts as a kind of visual reconciliation of these oppositions, just as it serves to mediate between the otherwise harshly contrasted horizontal and vertical axes of the painting? The vistas opened up by such a reconciliation are, however, out of sight around the river bend, whose curve leads precisely out of the picture plane. This effect is more provocative than a straightforward vanishing point that conforms to the direct recession of sight. Perhaps Gwyn's promissory impulse toward a reconciling *further* view is thus inseparable from his pushing toward the limits of his two-dimensional medium. As is

so often the case, a prophetic insight brings its bearer to the limits of expression; and that curving river's disappearance surely brings Gwyn into the company of those painters who have not only made art of the frontier but also reached the frontier of art—in this case, the frontier within the plane of the medium itself.

In 1982, the year before *Rio Grande Bridge*, Gwyn painted studies and then a finished canvas of another bridge (*14′0″*), but with an entirely different point of view from the one we have been studying. One study shows us a deep, boxlike frame of blue, through whose far side we see a few bands of color marked by a bright yellow brushstroke set like the bull's-eye of a target near the center of the board (the final canvas makes this center geometrically exact). This sketch is one of the most abstract of Gwyn's works, and it shows us the essentializing vision that a representational painter may now consciously or unconsciously derive from so-called abstract art. Albers or Stella may come to mind, or the slowly vibrating fields of meditation juxtaposed like land or sea against sky in the works of Rothko: "When I look at the works of Rothko, I sense he is telling us something about life."[14] In the study, Gwyn hastily gets down the visual strike, not bothering for the moment to define the blue cube as a more than merely optical tunnel—obviously struck by that odd passageway through the blue shadow to the distant view, whose consequently exaggerated luminosity is accented by the spot of bright chrome yellow. At a visual level, that's it! And without it, there's no compelled or compelling painting. (We could pause here to review how often in Gwyn's work an entire schema seems to rise from the primal opposition of blue and its complementary yellow: the thin yellow median line in *Rio Grande Bridge* as opposed to the thin blue river; the many highway paintings in which the yellow stripe interacts with the intense blue sky; the strong play of yellow barrels and blue sea in *Reef Point* [1988], of which Gwyn said, "I painted the barrel with the ocean because it was an exciting visual. As soon as I saw it, the hair on the back of my neck stood up and that was the signal! That is life telling you to go in that direction.")[15]

Moving to the final painting of *14′0″*, Gwyn adds a great deal while preserving the energetic core of the subject. Clearly, the interposing bridge is a massive object of attention, its solidity completely framing the view of the distant land, and its large inscription stressing how much this is a work about access. In a heavier manner than in *Rio Grande Bridge*, Gwyn foregrounds how our perceptions of the natural world are framed by unnatural constructs. Here, too, the bridging direction opposes the direction by which the eye moves into the landscape, although a dirt road leads us under the bridge. A luminous view beyond suggests the rewards of this journey; but, interestingly, there is a curve in the road. Gwyn is

clearly fascinated by this curve, which again tends to mediate the strongly opposed vectors of the painting and alludes to the further view such a reconciling bend might provide if one could somehow keep moving beyond the painting itself. The call to this directional turn is signaled by the curve sign on the yellow marker. Even in the study, this marker was noted as a rectangle that has been rotated; in the final version the added signal arrow prompts us to perceive it as a leftward swing, as if to pull the prior framing rectangle of the bridge toward a further altered version of itself. In other words, we're being asked not only to move through the frame but also to make a kind of perceptual turn in our framing devices and in our continuing directional course. What at first appeared to be the eye's target or destination in the painting turns out (this phrase takes on new interest now) to refer us still elsewhere via another turn. The use of an actual sign to turn us and to refer us to an unseen and deferred scene reconfirms our sense of metaphor or trope at the exact center of Gwyn's realism. The leftward diagonal slopes of the far hills give that turn a naturalized and ascending dimension.

What seems to be a realist painting of orientation thus becomes a work of reorientation. In *14'0"* the passage through the frame is further loaded by an almost ritual association of descent, reemergence, and possible reascent into the light, as if there were a quasi-religious ceremony involved. The pencil sketch and oil painting of *Paul's Culvert* (1989) suggest a similar, nearly ritualistic progression, although here the visual play of descent and ascent is far more striking. The totally dark frame of the tunnel sets off the graceful lift of the far mountain, and the distant ascent is all the more effective because the tunnel shows no apparent exit on its far side. The tunnel is an intrusive human construct, geometrically rectangular— not unlike the shape of a painting. But characteristically Gwyn modulates any simplified opposition of human and natural forms, for the tunnel is framed by a truncated pyramid of pale concrete whose sloping sides guide the eye toward the horizon's far-off, "natural" apex of this pyramid, as if to say that the tunnel and the mountain are not just complementary but of a piece. The painting will not give us one without the other. Rather, we are invited to journey, via the artificial and dark descent of human constructs, toward an intensified reemergence in the natural world. (*Subway* is a variant of this subject, where the dark black cube at the end of the platform offers nothing but an unrelieved journey into darkness.)

In suggesting that the tunnel in *Paul's Culvert* has the unnatural, rectangular shape of a painting (in the sketch, the pencil marks are heaviest here), Gwyn is not merely aware that his art and artifice are set off from nature; he also regards the unnatural locus of his art as a kind of foyer or passageway to a more penetrating and enhanced view of the world.

From the Mystery Rites of ancient Greece to the surviving uses of hogan and kiva in the American Southwest, human beings often have resorted to ritual descents or artificial enclosures within whose darkened or formally demarcated spaces we may receive revelations otherwise unavailable in the normal course of our lives. Perhaps art, however darkly shadowed or brightly lit, is one such ritual chamber or passage.

Black Mesa (1982) belongs to this discussion, for here, too, while Gwyn takes us across the harshly interposed and dark-toned human space of the road and leads the eye toward a natural ascent, the mesa in question is actually a well-acknowledged sacred place in local Native American religion. Instead of traveling along our normal course with a technologically advanced speed that would take us past the mesa in moments, we're asked to stop, to pull off the road. As William Peterson has said, "'Stepping from the wheel' seems an appropriate phrase. Tellingly, among Hindu Vedic scholars, this phrase has an expanded meaning. It describes a religious sensation, the seizure of a privileged state of being out of life's normal flux. The composure and stillness of the landscape, and the sudden isolation that you feel, somehow give the moment of apprehension a quality of endlessness."[16] Even beyond the act of stopping, however, we are asked to switch our highway orientation by ninety degrees. And as if this weren't enough, we're further invited to move upward from horizontal to vertical progressions.

Gwyn's original study for this painting sketched the road in its actual seasoned pale gray; but in the studio he felt the painting "dictated its own inner needs," requiring the road to exert "a stronger visual punch."[17] So he gave it a new surface of tar, and, as mentioned earlier, he found the road resurfaced a short while later. What interests me here is that the *visual* needs of the painting intersect so powerfully with its metaphorical and even mythic implications. Whereas the sketch shows a more muted relationship between road and mesa, the painting updates and blackens the road to sharpen its contrast with the ancient, natural form of the mountain. In addition, Gwyn paints yet another yellow stripe, this time in an unbroken line that stretches right across the canvas. He thus accentuates what stands between us and the mesa, while ironically reinforcing the suggestion that what keeps us from this natural and sacred view is precisely the road along which most of us are usually speeding. In the visual field of painting it is therefore up to us to choose a different "road," to cross one of the barriers set up by our constantly moving and resurfacing technology and to advance at a different, meditative pace towards an archaic, hallowed site. The "turn" or reorientation noticed in other paintings is now at its

most radical. Once we advance across the desolating road, we can move either by vision or on foot toward the crest of this mountain, in which it is believed God dwells. Faint lines of ascent seem indicated, as do more purely visual paths of rock clefts whose darkness recalls the black road while turning its direction straight upward.

By rotating us within the horizontal plane and then also turning us upward, Gwyn has painted a very different "way" that counterpoints the road and the preceding course of our lives. The point, however, is that *both* roads exist, both ways of looking and traveling. After all, we come to this place most conveniently by traveling down the road, just as our visual appreciation of the mesa is dramatically charged by the strong, black asphalt foreground. But if we want something more than sheer paving, and something greater than the secular horizontal advance of our lives, then we also need to turn off, to stop the car, to go against the grain, to make what may feel like a formal or ritual passage *across* the smoothed surfaces and strong directional lines laid down for us by our society (or its Department of Road Works), and to journey into a different dimension whose surfaces and depths precede our own recent pathways by millions of years. The strength of Gwyn's painting is its unflinching depiction of both courses at once, its way of presenting not just what is here now but also what has been and what may still be possible.

This may be a good point at which to think further about the probable relationship between Gwyn's work and the culture of his region. There are definitely strong links among his sense of alternative paths (to those of the dominant Anglo-American society), his susceptibility to a nearly mythic ecological consciousness, and his hallowing attention to the land. And these interlinked senses surely are connected to Gwyn's residence in one of the few regions of the United States where one can still feel the strong presence of Hispanic or indigenous American cultures. Many of his titles are derived from Spanish or Indian languages—as if to remind us that the scenes thus named lie at a certain remove from the representations of an otherwise homogenized and domineering culture.

Once we perceive the issues and strong visual motifs I have been isolating here, we can see them at work throughout the entire range of Gwyn's paintings. So many of them present variously foregrounded roadways whose direction the eye must oppose in order to reach the ocean, the palm tree, the distant land. Clearly, there is a large part of Gwyn that loves the onward sweep of the road and that relishes the immense swag and power with which it slices or occasionally thunders through the landscape. And yet the counterhighway pull of *Palm* (1983), *Ocean/Highway I* (1983), and *Ocean/Bridge* (1985)

do for the palm tree or ocean what *Rio Grande Bridge* or *Black Mesa* does for river or mountain. Similarly, various mediating devices almost always are at work, particularly in the form of curves that synthesize or complicate opposed axes—the radiating fronds of the palm, the long, asymptotic swing of *Ocean/Guardrail* (1985), the amazing counterrhythms of *Interstate Guardrail* (1983-84) and the *Road Curve* paintings (1989). So too, in almost all of them we are invited to meditate not only on our human ways but on other larger "ways" in the hillsides, the vegetation, the river, or the skies around us.

This last point connects the highway paintings to those without roads. In fact, the earliest works represented here, from the mid-seventies, capture what we might call lightways, cloudways, stoneways. These works address distinct kinds of travel: in *Dawn Ascension* and *Dawn Progression* the titles cue us to the true subject, which is not so much the land-forms as the journey of the daylight across them. The triptych form emphasizes the time-lapse element, while perhaps harking back (in a rare instance of allusion, like that in *Arroyo Tondo*) to formal structures found in early religious art. A title such as *Dawn Ascension* strengthens this association, leading to a reverential regard for the ascending light. But even without a religious cast, these works (including *Cloud Progression, Arroyo Triptych, Arroyo Tondo,* and *Arroyo San Marcos*) all have a profound and patient regard for the rhythmic passages of light, of clouds, of an arroyo's rock and silt. The arroyo paintings actually are at the threshold of highway paintings, since the raw canyon gullies are the earth's own roadbeds. So we can recognize how intrinsically Gwyn's highway works arise from a deep fascination with the various ways and rhythms of more than merely human evolution.

Walt Whitman, one of our greatest celebrants of the open road, declared, "these states tend inland and toward the Western sea, and I will also." Gwyn's own career includes repeated forays west to the Pacific; and in several respects these journeys—recently more frequent—carry his art toward new reaches. In a characteristic overlap of personal and public impulses, Gwyn renews the pioneering thrust of his country. And just as this national thrust came up against a kind of terminus, so too Gwyn's work approaches one kind of extremity in its own development. We might see the West Coast as the literal end of the transcontinental highways; indeed, several of these ocean paintings are of parking lots, as if to question where exactly one might come to a stop when the road ends, or what demarcated position to take up when faced with the vast, unmarked ocean.

In other ways, we might view Gwyn's West Coast paintings as redefinitions of the frontier. By frontier I mean the boundary or threshold of a continuing quest, one that in Gwyn's case becomes in part a drive to the limits of representational painting. To reach a limit of physical expansion may force one toward a more metaphysical and meditative journey of the spirit, a tendency we have already found implicit within all of Gwyn's work.

Particularly in southern California, Gwyn could have found the ultimate extravaganza of freeways, overpasses, and interchanges. It's as if the mere fact of hitting the ocean forced the road-building and highway-traveling impulse back on itself into an excess of tangled loops, just as the materialistic or extraverted drives of the nation seem to have heaped themselves up to their greatest exhibitions at the very point where they meet the land's end. There surely are connections among the Los Angeles freeways, the extravagant and inventive outer displays of wealth and style, the industries of physical fitness and cosmetic self-remaking, and of course the movies (the term itself is suggestive—to what extent do these constantly rolling reels satisfy the nation's compulsion to keep moving when it has nowhere further to go, the film reels like surrogate wheels unwinding ribbons of celluloid highway?). As we might expect, however, Gwyn remains true to his overriding desire to get beyond or *across* the road rather than merely to follow it, to reorient the journey away from its more material or technological obsessions, leading instead to a stance that does greater justice to the natural and spiritual worlds.

It is therefore not surprising that while several of Gwyn's West Coast works do include parking lots or highways, the great majority of them acknowledge the inner and outer distances he has traveled (and is still traveling) by marginalizing and shrinking the actual presence of the road, or by reducing its dissimilarity from nature, or by abandoning it altogether. To see where Gwyn has come, one has only to contrast the delicate, threadlike trace of the coastal road in the *Big Sur* paintings (1989-91) with the vast amount of space taken up by the roads in *Texas Overpass, Guardrail/Median, Two-Lane Road Cut,* and other works looked at earlier. Now if the road survives, it does so as the merest token of humanity's precarious place and journey, a tenuous strand clinging to the sloping end where the continent shelves into the sea. The human presence thus has been reduced to a shred in many of these paintings, and the object of fascination is now defined as everything that lies beyond humankind and its works—unless among such works we now include paintings like these. I

would suggest that Gwyn's achievement here pursues his long quest to turn us from one kind of work and journey to another.

Psychologically, the *Big Sur* paintings invite the viewer also to temper that part of the mind associated with material achievements and intrusions. Even the high speed and perspectival thrust that made up much of the tension in the highway paintings is now stilled. In other words, we are invited to set aside (as the paintings themselves do) not only the physical land and its roads but also our own correlative interests and to look away from all we know, gazing out to sea with a more open, self-forgetful, and diffused attitude—one that is less narrowly concerned with instrumental goals and destinations. One of the features that make Gwyn's seascapes remarkable is the fact that despite this kind of diffusion or relaxed openness to a vast new vacancy on which the eye would seem to have no purchase, the paintings nevertheless remain so crisp and focused. They have an even, widespreading lucidity of the scene itself and of the curiously aimless but alert consciousness that dwells upon it. Over a trackless surface that is as much water as reflected light, the only possible movement for the body or the eye is precisely that of floating—and the mind does the same, drawn into lucid reverie.

The sea has often had this kind of effect, particularly in literature and art—and Gwyn's treatment of it belongs to a distinctly American tradition. This tradition, especially since the nineteenth century, has looked to the sea as an alternative to the increasingly marked land. Whereas earlier marine art tended to follow the Italian, Dutch, and English interest in the sea as arena of trade and commercial or naval competition, complete with shipping, harbors, and scenes of naval conflict, later American artists such as Church, Kensett, or Fitz Hugh Lane turned to what Melville called "the watery part of the world" for a source of relief and release, an arena for meditation rather than for material triumph. Gwyn's preference thus far has been for the most pacific versions of this turn. His sea is not a dramatic, wave-ridden adversary but rather a calm, translucent medium of reflection and immersion—perhaps a mirror of what this aspect of his art seeks to include.

In saying that Gwyn's seascapes are at once diffuse yet crisply focused, relaxed yet highly concentrated, I am led back to several earlier suggestions regarding both a certain extremity within the work and what I might now call the substrate of its vision. An obvious sign of this extremity—particularly for representational art—is the frequency with which light seems to obliterate the perceptible world. One sees this forcefully in the most recent work: both the studies and painting

of *Santa Monica* (1990), *Morning Light—Big Sur* (1990-91), and *Morro Bay I* (1990-91). While Gwyn has always been sensitive to the way in which intense light occasionally seems to halo what it surrounds or to "white out" certain surfaces—*Mirage II* (1990) is an important hinge between late landscapes and seascapes—the ocean paintings take this sensitivity further, to the point of blanking out portions of the painting, suggesting that the most accurate depiction of such regions is no depiction at all. At such extremes, the quest to reach beyond the road or beyond the humanly marked world becomes a quest to go beyond painting itself—or for painting to include intervals of its own absence. This is a more radical equivalent of the silence in the work noted earlier, and a further exploration of those elements of Gwyn's work that have sought to "clear" the mind, to allude to unmediated forms of perception, and to take as an ultimate subject the pure, objectless content of space and light. In a way, the journey of Gwyn's art would here reach its fulfillment by painting its way full circle back to the bare canvas or blank piece of sketchpaper that is its origin. Not by chance, perhaps, that journey to the bare source brings Gwyn to the ocean, coinciding with mankind's return to the shores of its own evolutionary origins.

Such an extreme is only alluded to, however, in these late works, for they integrate patches of blank dazzlement as a way of *representing,* after all, a surface whose brightness lifts it past visible definition. What Gwyn may be reaching here is an image not only of pure light but also of the very basis of our sight. In the same way that the bare canvas or page underlies any image, so these seascapes offer us surfaces and depths that may metaphorically also represent the very faculty of sight that underlies any actual seeing. By painting large expanses of sea that offer us nothing *particular* to look at, he allows us to reach a contemplative view of looking itself—and just as the sea becomes a vast, pristine surface for registering sheer light, so it may suggest a version of an empty but light-filled retinal net. With this in mind, we might look as closely as possible at the actual surface of Gwyn's seas (particularly those that are most brightly lit and yet still blue), noticing how carefully they are painted as a kind of floating net or subtly vibrating field of intermingling brushstrokes. If the sea seems silken here, Gwyn gives us the illusion of seeing the actual fibers of that silk, as well as the spaces in between. This finely woven network or screen of minutely contrasted marks in turn suggests the system and faculty of differentiation that forms the basis of all perception. Perhaps the retinal and neural substrate of our seeing, like the makeup of light and of reality itself, is most accurately representable as a wavelike field or tissue of pathways (microhighways?) of energy made

up of barely discriminable masses, filaments, or pulses. Once again, Gwyn is perceiving and showing things "from the inside out." (This may explain why his seascapes show no lines of surf—as if to stress the minute "waves" that make up the very structure of water, of light, of perception, and of the world itself.) To his highways, stoneways, cloudways, we may thus add not only these latest water-and-lightways but also their implied portrayal of the ways of seeing and of being.

And yet one might object, "Wait a minute! These are simply paintings of the empty sea!" Such a statement is true, but not entirely true. It would slight the word *paintings*. And it would slight the hypnotically repetitional fullness with which Gwyn captures the mingling shift and sway of translucency, or the cumulative rhythms with which each tiny, pyramidal facet of the water either reflects and absorbs the light or casts its own shadow on an adjacent flake of sea. As elsewhere in Gwyn's work, but with a finer grain, the seascapes are very much about the strange *copresence* of emptiness and plenitude, of darkness and light. It is a remarkably American copresence, one that haunts our history, our psyche, our restless riding of the verge between substantial power and utter desolation. The West Coast paintings continue Gwyn's meditation on this polarity while also bringing to it a more philosophical and metaphysical cast, signaled by the calmer tone of these works, in which the very question of fullness or emptiness is resolved according to the mystical perception of "both at once." In a way, Gwyn's mesmerizingly beautiful sea-surfaces are the visual equivalents of a nearly silent or wordless chant in which nothing and everything is heard.

In moving from land to water, and then from water to light-filled horizons, Gwyn dematerializes and spiritualizes the subject of his art, bringing his robust realism into its most refined attunement with spiritual intuition. Apart from the winnowing of vision and content described above, there are other formal signs of Gwyn's journey. Whereas so many of the earlier highway paintings were dominated by strong torques and countercurves by which Gwyn was wrestling with and against the otherwise purely recessional axis of perspective, now many of the canvases take on an elongated horizontality, as if the curving impulses in *Interstate Guardrail, Rio Grande Bridge, 14′ 0″, Road Curve*, and others were now being satisfied in a way that literally pulls the shape of the canvas itself sideways to a widening of vision. By a brilliant stroke, this widening in no way sacrifices farsightedness, for these views invariably stretch out to the horizon, while their very thinness suggests the kind of horizontal narrowing or squinting by which one peers into the distance. And since the painting is like a horizon, it is as if the farthest phenomenon in the field of vision were brought up close. Like the bays

and margins of blinding light, or the expanses of color fields broken only by a minimal contrastive band (*Big Sur Horizon*), these exaggeratedly shaped canvases probably represent a limited case within the career rather than its more sustainable middle ground—a case whose extremity brings Gwyn's realism as close as it has yet come to the conceptual formality of a purely abstract art. As Mark Stevens has written, "No mere rectangle can hope to encompass the full extent of the Western space. The excitement consists of its very boundlessness, our knowledge that it continues beyond the corner of the eye (and past the frame of the painting). Such a space can only be implied. The narrow strips, which mirror the horizon line, do exactly that. Their radical confinement makes us dream of a radical expansion. Their exaggerated length stretches our seeing. We become aware of the edges—of perception, of landscape, of ourselves."[18]

Before leaving the West Coast paintings, I would like to look at the *Piedras Blancas* works, which simultaneously take us further out in Gwyn's work while also steering back to the landscapes of the interior. These are mysterious, brooding meditations that scrutinize two rocks protruding from beneath the waters off the California shore. Several sketches precede the long panel finished in 1991, a work that may mark yet another turning point in Gwyn's career. One of the most effective ways to regard this portrait of the rocks is to situate them literally and metaphorically beyond the physical, artistic, and mental shorelines described above—to come at them having made the clearings and departures elicited by the earlier work. Like an almost concurrent painting, *The Grove, Piedras Blancas* seems to stand out in that region that Wallace Stevens, in a terminal poem entitled "Of Mere Being," called "the end of the mind, / Beyond the last thought." These chunks of primal reality are reachable only by moving offshore, continuing the westward journey by a "voyage" of sorts or rather by an *immersion,* since there is no available craft other than that of Gwyn's art. The rocks are partially immersed while seeming to protrude upward from beneath the very surface of visibility, as from another realm; hence their great admonitory power as relics or harbingers of another era or world. They are figures of archaic permanence compounded with tidal change, and Gwyn's art captures this compound with a powerful yet delicate rendering of their isolated masses sheathed in light and partly encrusted with vegetation along highwater marks. Resilient yet subject to altering lights, tides, and vegetal growths, the rocks mark the westernmost verge of Gwyn's art while also serving as possible signposts, rough springboards, or even uncompromising, metaphorical self-portraits of the artist at a transitional point in his already considerable and solid achievement. So, too, there is an uncharacteristically *transitional* light in this and other of Gwyn's

latest paintings. Unlike his usually high, brightly fixed midday light, Gwyn has chosen the lavenders and muted violets of twilight or suffusing cloudlight, giving the surfaces a softer yet more independent radiance while still allowing these white rocks to glimmer with nearly phosphorescent intensity.

The subject of *Piedras Blancas* has yet further properties of initiation, transition, or exploration. Literally meaning white rocks, they connote a kind of tabula rasa, the challenging "blankness" on which one might inscribe something as if for the first time. It was its blankness more than its elevation that made Mont Blanc such a sublime object for Romantic poets, while a similar sublimity haunts the blank icebergs of Gwyn's great precursor, Frederic Church. If one of the predominant motives in early American landscape painting was the depiction of an allegedly virgin land or blank slate, then *Piedras Blancas* is one kind of bleak endpoint for that motive. And yet such bleakness—the rough, uninhabitable isolation of these rocks—is surely tempered by the almost magnetic resilience, the shimmering metamorphic promise and otherworldly power they exert. As the poet Elizabeth Bishop wrote fifty years ago, "we'd rather have the iceberg than the ship, / although it meant the end of travel." The end of literal travel, that is, and the confirmation of a spiritual quest.

It is hard to pull away from *Piedras Blancas,* hard not to keep watching the rocks to see what they next become as the light and the tide shift. Hard to relinquish their economy yet sufficiency, or the kind of patience they embody and instill. If Gwyn likened his highways to Monet's repeated waterlilies as "metaphors of life," these offshore rocks combine the vaporous lily pads with the stored endurance of Monet's stacks of grain or even the floating stone of his cathedrals; but to that compound Gwyn adds his own uningratiating, stubborn insistence on the hulks and grit of an uncultivated world. At once realistic yet dreamlike, their suggestiveness becomes almost infinite—a weird blend of trans-Pacific Zen minimalism with Ruskin's moral realism (we might recall his lectures and drawings of rocks). Like the object of another late Wallace Stevens poem, "The Rock," it is finally their unadorned barrenness that makes them such fertile iconic ground for the imagination.

Once we register the transitional light of *Piedras Blancas,* we notice it elsewhere in Gwyn's late works, even those that return to landscapes of the interior. Yet more interestingly, it is the color of this light that reduces the difference between Gwyn's most recent roads and the natural world. This alternative to sidelining or abandoning the road is now very much in play, not only in the coastal roads of *Gray Whale Cove* and *Ocean/Highway* (1990-91) but also in the concurrent New

Mexican *285 North*. This latter painting is exactly the same size and shape as *Piedras Blancas*, and it is impossible not to notice the similarity of mood and effect. In such lyrical landscapes, where the softly modulated lavender road flows through similarly hued regions that once were inland seas, one senses that Gwyn comes home to a more fluent, less conflictual vision of the world. There is a new attunement and serenity here—and it is but a short step beyond the margin of such works to the "pure" later landscapes of *Jemez* or *Guadalupe Foothills*, where there are no roads, no signs of humanity.

Gwyn has spoken of his desire to reach such a point: "And eventually, I want to get back to the pure landscape, to painting settings where man hasn't intervened in nature's beauty. . . . Maybe, after all, my work is really about man the plunderer. I want to be able to portray in my work a sliver of purity. Eventually I want to show the nature that man hasn't disturbed or marred."[19] This is a deeply utopian impulse, one that has been at the core of landscape painting for a long time. Gwyn's curves and luminous vanishing points have led us there, as have his intuitively charged and radiant surfaces—reminding us that utopia may be less an actual, habitable place than a certain achievement of seeing and of contemplation; or rather that we have no chance of "getting back" to a natural utopia unless we first travel through a change or turn in our own course and in our own natures. The need for this kind of restorative turn has taken on unprecedented urgency as a devastatingly "impure" planet moves toward another millenium, and as humankind discovers itself in want of ways to combine technological prowess with a more receptive, sympathetic intuition of forms of coexistence among ourselves and between us and the earth. The frontier and region for conquest now is precisely not the land but ourselves. Without a trace of polemic, Gwyn's work has marked out a series of waystations and switching points along the course of this potential journey. In a sense, this teleologist of nature and of the human spirit has been building his own roads and bridges, achieving what he calls "those very rare and exalted moments when we sense that we have done a piece of work that really represents a step ahead and from which we can see new horizons. These moments make all the difficulties worthwhile; these are the moments of joy."[20]

ENDNOTES

1. Mark Stegmaier, "Woody Gwyn," *American Artist* (March 1988): 51.

2. Quoted in Keith Watson, "Down the Road Apiece with Painter Gwyn," *Houston Post,* May 15, 1983, p. 1.

3. Quoted in William Peterson, Introduction to *Recent Paintings* (Midland, Texas: Museum of the Southwest, 1986).

4. Quoted in Watson, "Down the Road Apiece," p. 5f.

5. Quoted in M. J. Van Deventer, "Woody Gwyn," *Art Gallery International* (Jan.-Feb. 1988): 32.

6. Quoted in Peterson, *Recent Paintings,* (Midland, Texas: Museum of the Southwest, 1986).

7. Quoted in Van Deventer, "Woody Gwyn, " p. 32.

8. Ibid., p. 29.

9. Ibid.

10. Ibid., p. 32.

11. Ibid.

12. Quoted in Paula Fitzgerald, "Southwestern Vision," *Designers West* (April 1989): 122.

13. Quoted in Stegmaier, "Woody Gwyn," p. 51.

14. Quoted in Van Deventer, "Woody Gwyn," p. 30.

15. Quoted in Fitzgerald, "Southwestern Vision," p. 124.

16. Peterson, *Recent Paintings,* (Midland, Texas: Museum of the Southwest, 1986).

17. Ibid.

18. Mark Stevens, *Woody Gwyn* (Santa Fe: Gerald Peters Gallery, 1988).

19. Quoted in Van Deventer, "Woody Gwyn," p. 32.

20. Quoted in Stegmaier, "Woody Gwyn," p. 51.

SELECTED BIBLIOGRAPHY

Fitzgerald, Paula. "Southwestern Vision," *Designer's West* (Apr. 1989): p. 122-124.

Peterson, William. Introduction to *Recent Paintings.* Midland, Texas: Museum of the Southwest, 1986.

——. "Woody Gwyn," *Artnews* (Oct. 1988): p. 189.

Stegmaier, Mark. Woody Gwyn, *American Artist* (Mar. 1988): p. 46-51.

Stevens, Mark. *Woody Gwyn.* Santa Fe: Gerald Peters Gallery, 1988.

Deckert, John *Arts Magazine* (Sept. 1980): p. 15.

Van Deventer, M. J. "Woody Gwyn," *Art Gallery International,* (Jan./Feb. 1988): p. 28-32.

Watson, Keith. "Down the Road Apiece with Painter Gwyn," *Houston Post/Sun.,* May 15, 1983.

W O O D Y

GWYN

Hogback

Oil on wood panel

2.5″ x 8″

1990

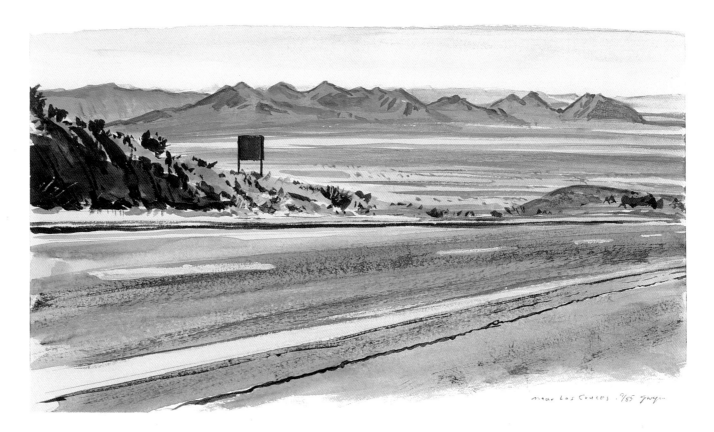

Saint Augustine
Pass Study
Watercolor
9″ x 14″
1984

Barrancas Study
Watercolor
3″ x 12″
1989

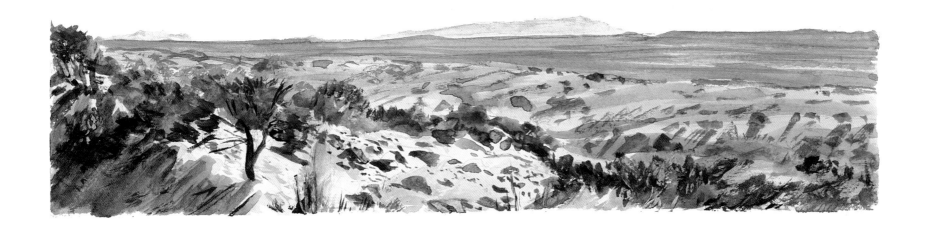

cloud shadow
cobalt violet - black

← deeper

Study for Jemez

Sketchbook

Watercolor

12" x 18"

1990

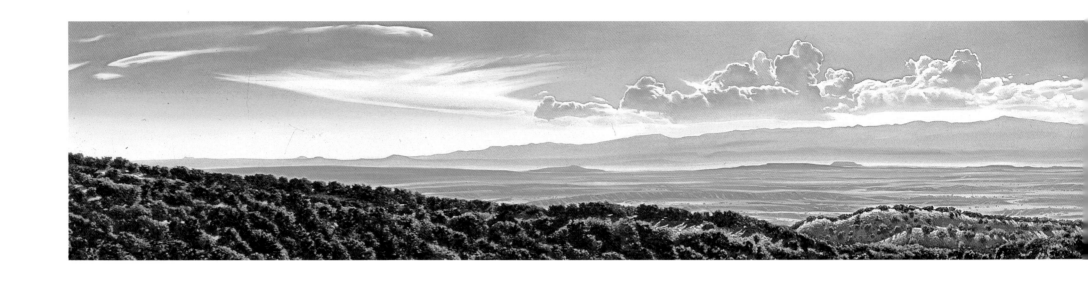

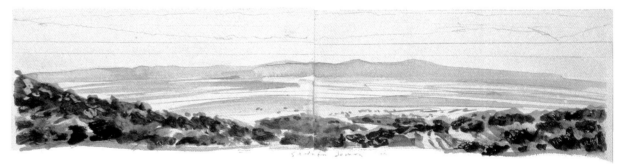

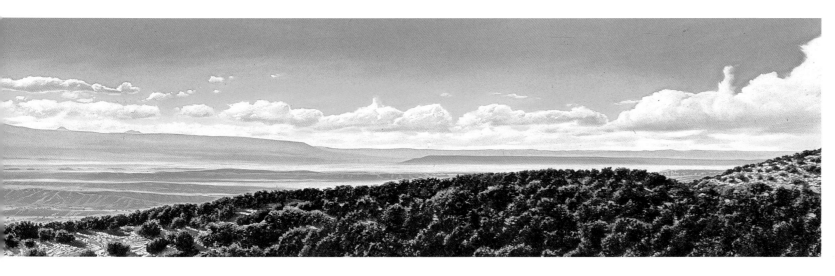

Jemez
Oil on canvas
24″ x 192″
1991-92

Study for Jemez
Sketchbook with foldout
Watercolor
24″ x 20″
1990

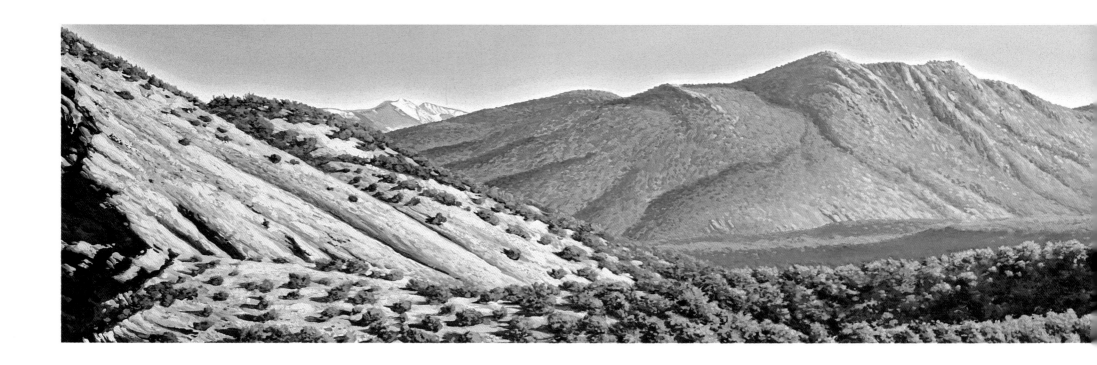

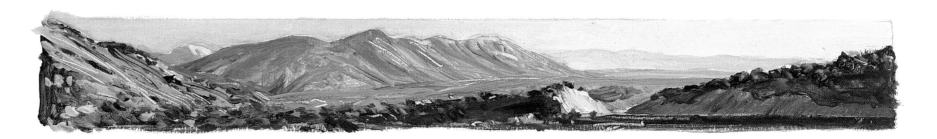

Vallecitos

Sketchbook

Oil on museum board

1.5″ x 13″

1990

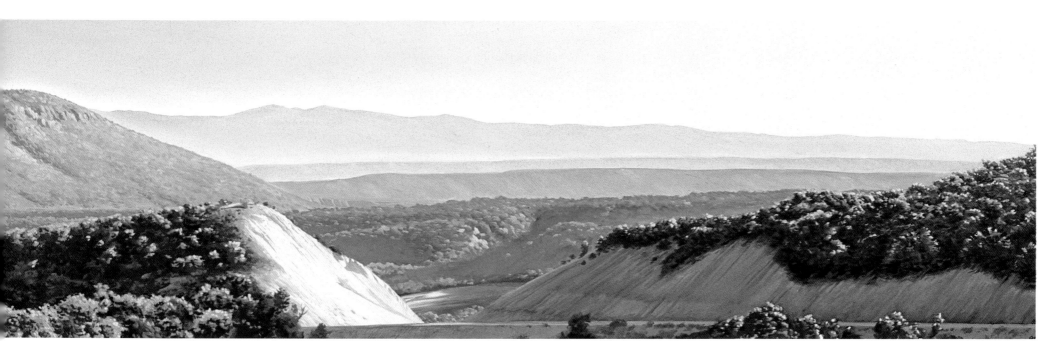

Vallecitos

Oil on wood panel

26" x 78"

1990-91

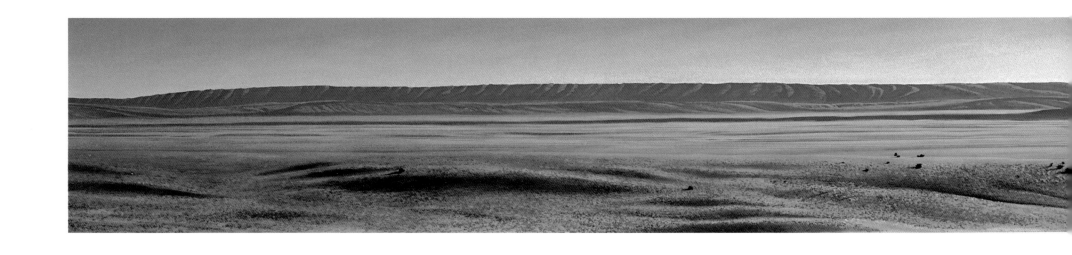

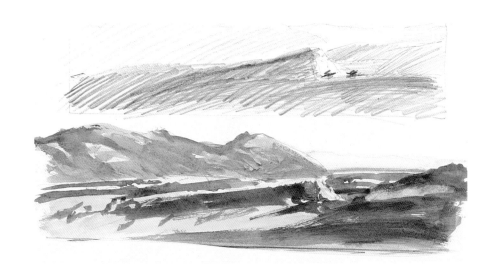

44

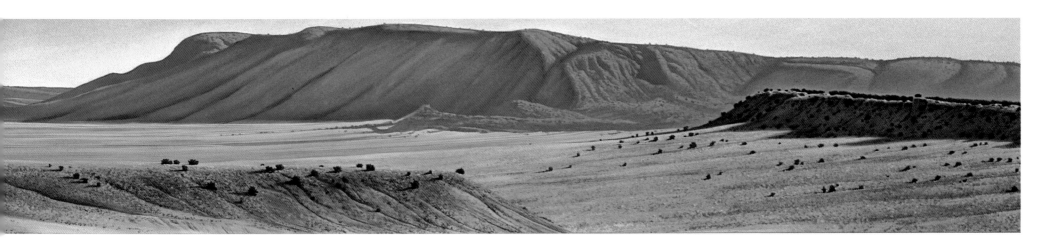

Cerro Pelon
Oil on canvas
24″ x 192″
1986-87

Foothill Study
Oil on wood
panel
2.5″ x 8″
1989

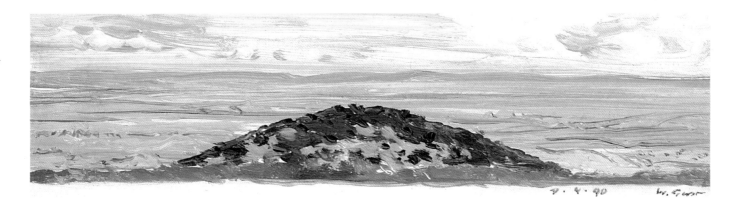

Study for Vallecitos
Mixed media
12″ x 16″
1990

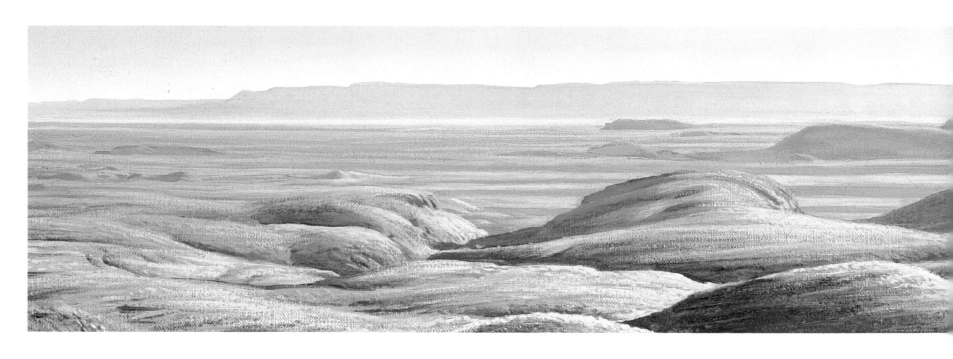

Guadalupe Foothills
Oil on canvas
4″ x 28″
1991

Guadalupe Foothills
Watercolor and graphite
12″ x 14″
1990

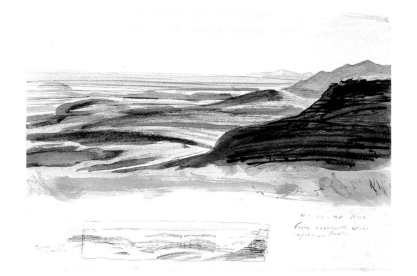

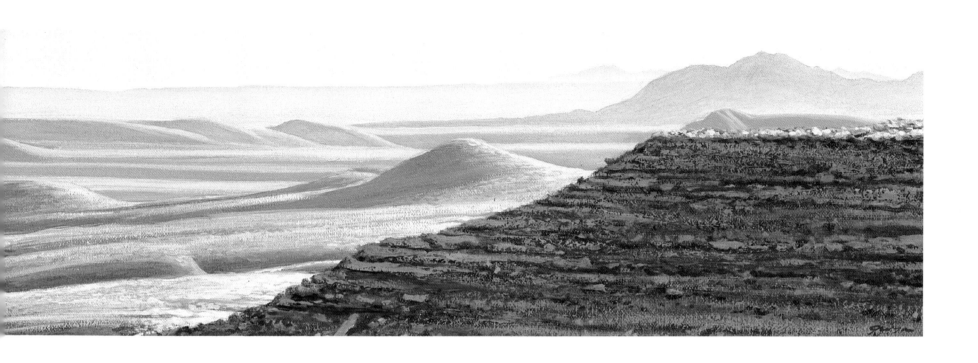

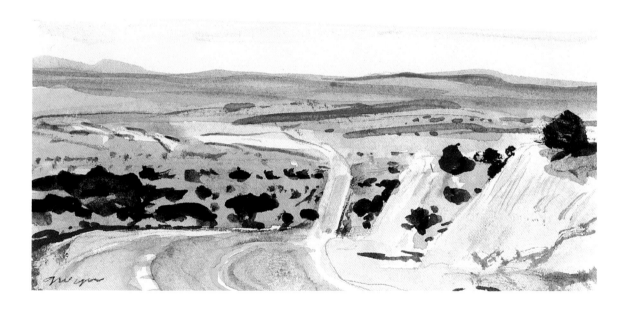

Study for 285
South
Sketchbook
Watercolor
3″ x 5″

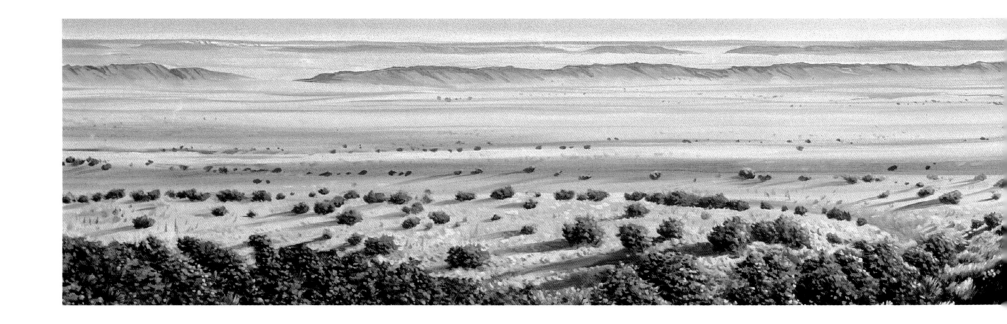

48

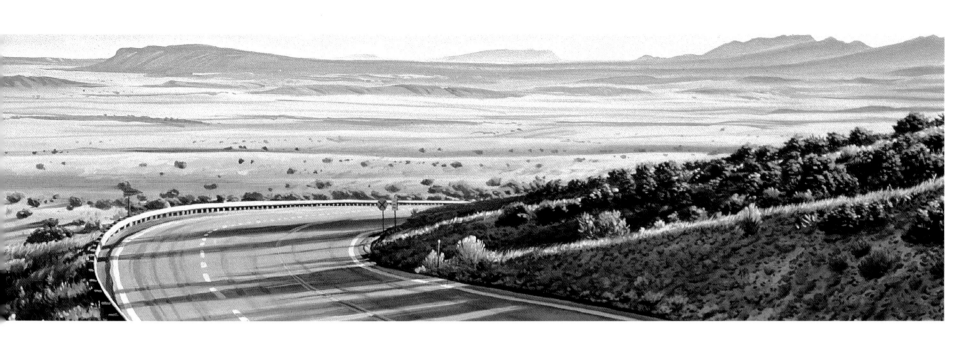

285 South
Oil on canvas
9" x 66"
1990

Study for 285 South
Watercolor
4" x 18"
1989

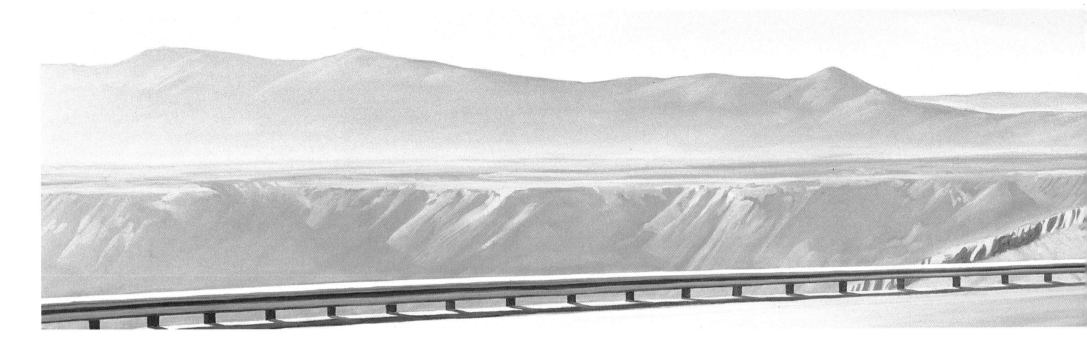

285 North
Oil on linen
12″ x 84″
1990

Cloud and Barranca
Sketchbook
Watercolor
8.5″ x 10″
1988

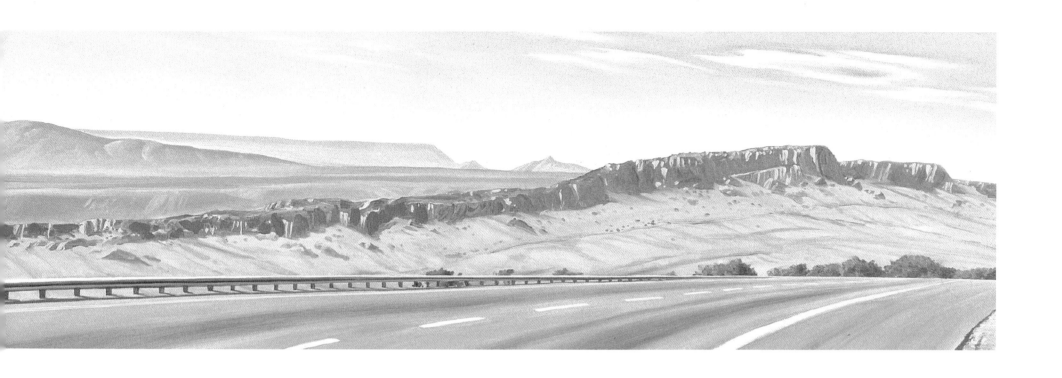

51

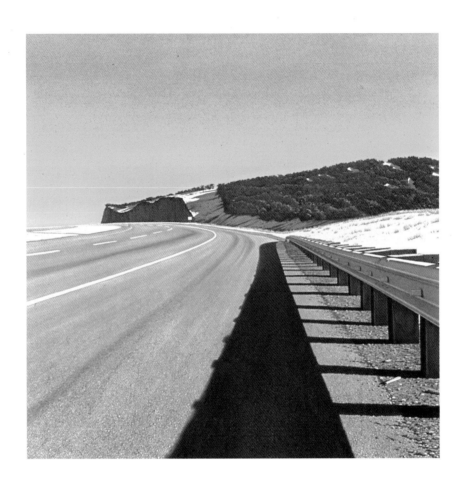

Guardrail/Median

Oil on canvas

72″ x 72″

1983

Guardrail
Oil on canvas
72″ x 72″
1983

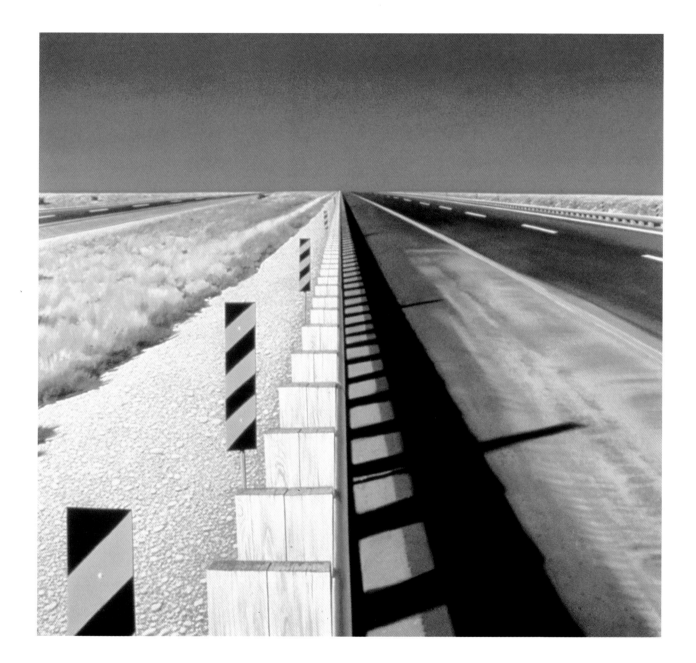

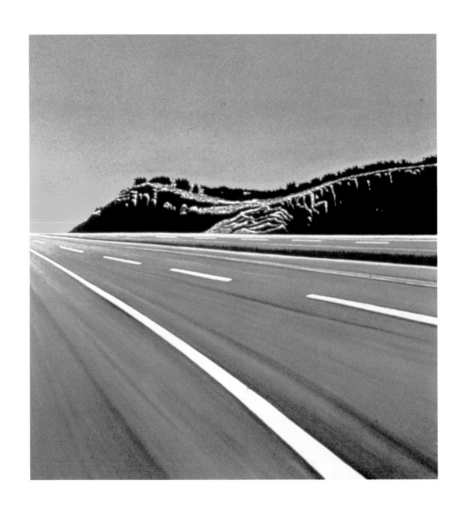

Interstate
Oil on canvas
72″ x 78″
1980

Ice Melt
Oil on linen
48″ x 60″
1983

54

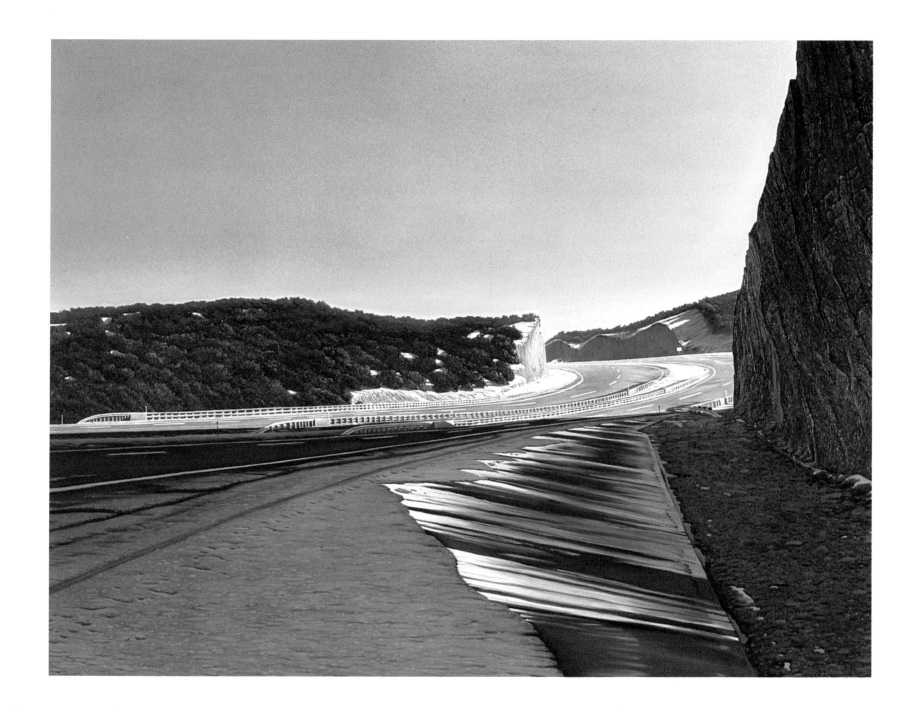

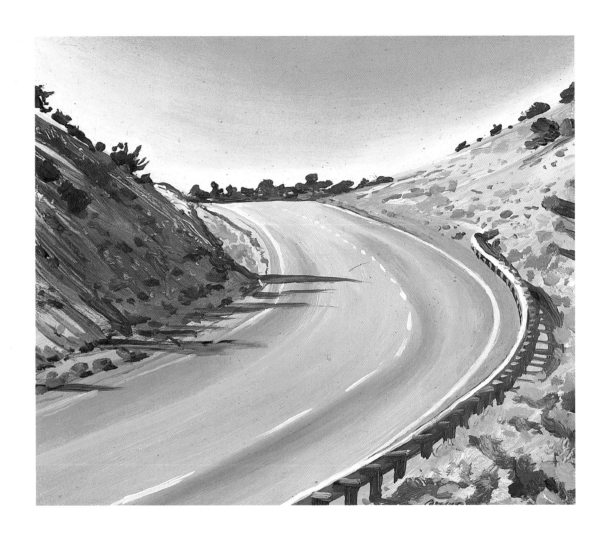

Curve
Oil on wood
9″ x 12″
1981

Interstate Guardrail
Oil on canvas
78″ x 84″
1983

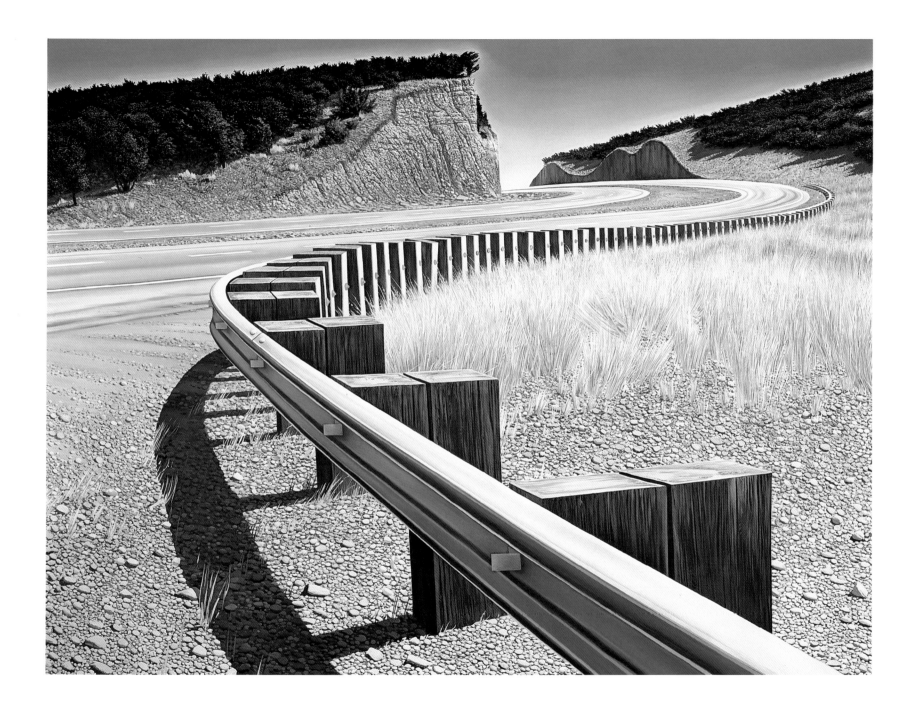

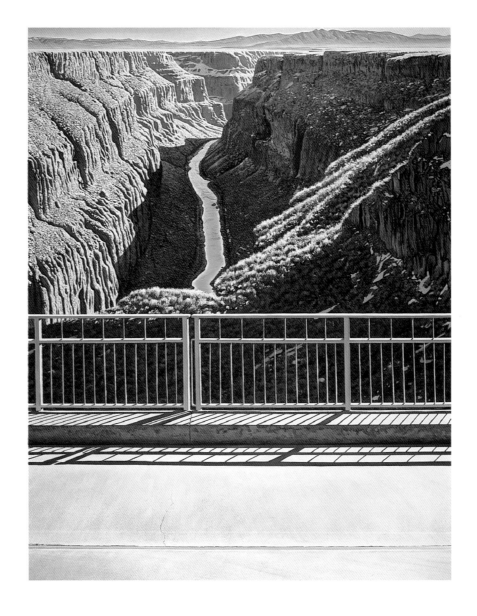

River Bridge
Oil on canvas
60" x 48"
1982

Roadcut
Oil on canvas
48" x 60"
1981

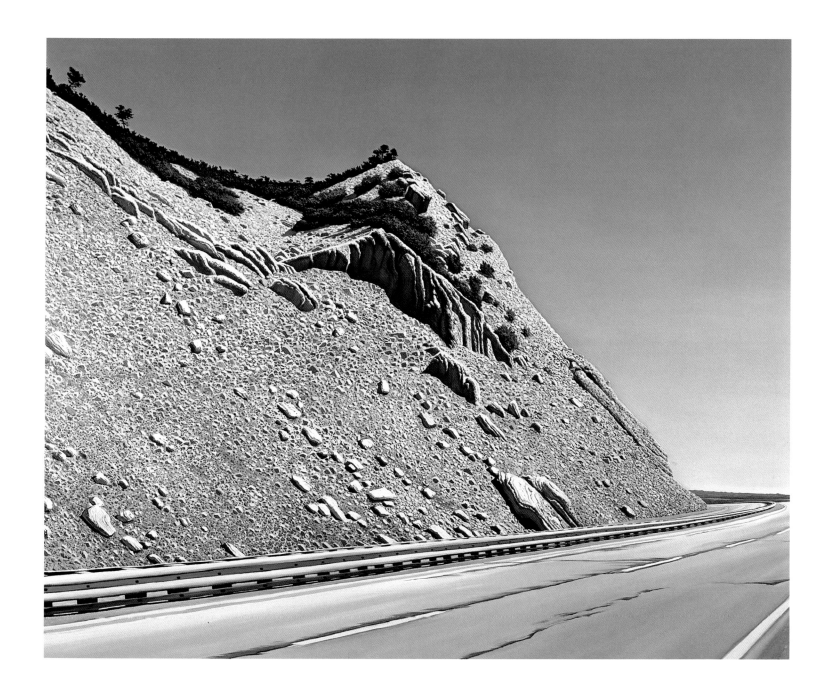

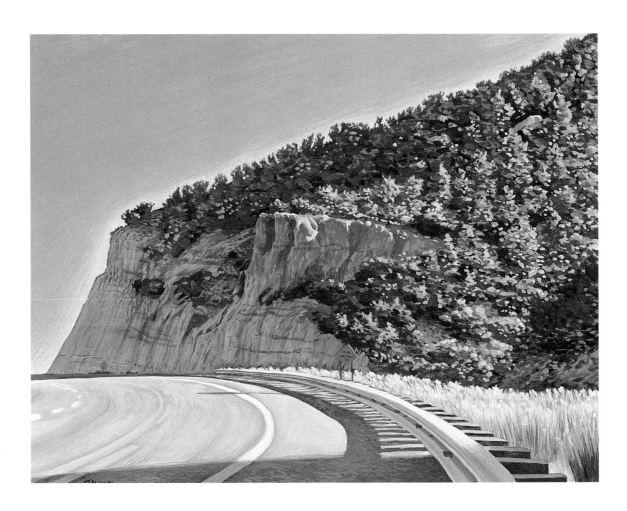

Road Work
Egg tempera
12″ x 18″
1988-89

Study for Road Work
Watercolor
Page: 5″ x 9″; image: 3.5″ x 4.75″
1991

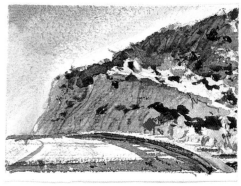

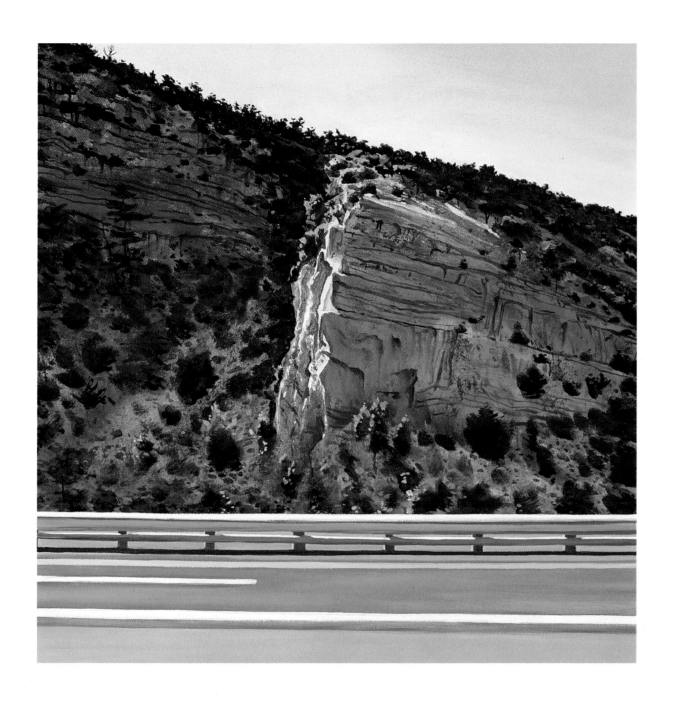

Apache Canyon

Oil on canvas

24″ x 24″

1983

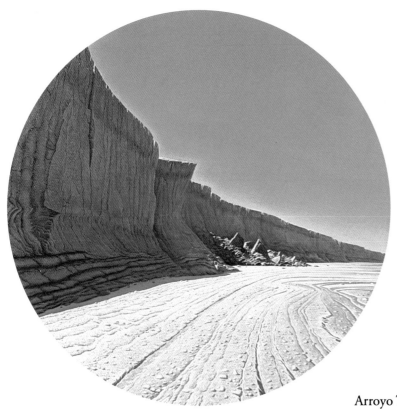

Arroyo Tondo
Oil on wood
36″ diameter
1979

Arroyo Triptych
Oil on canvas
12″ x 36″
1979

62

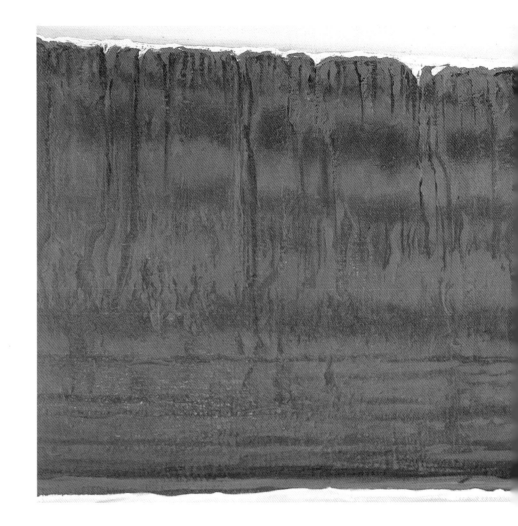

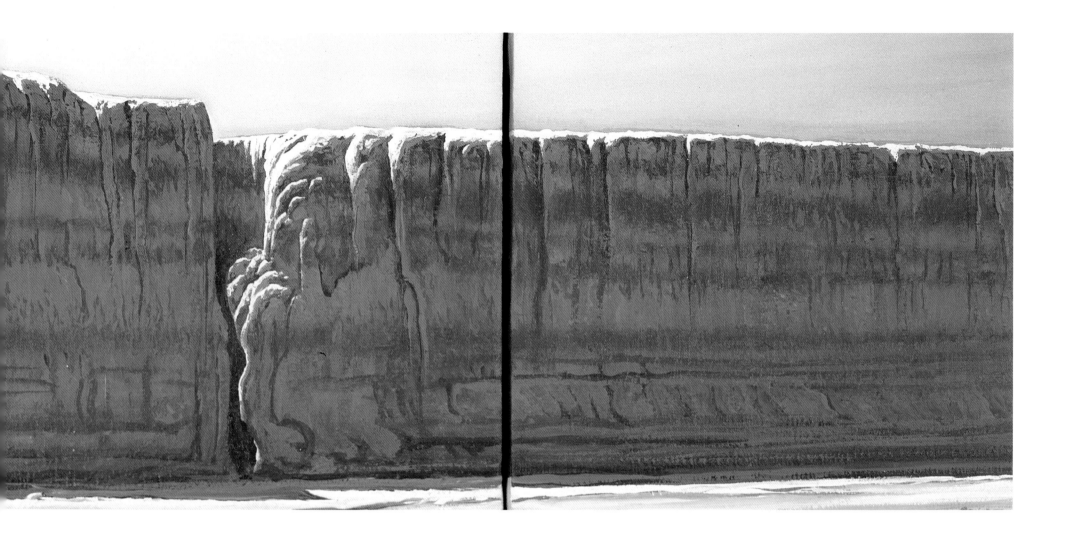

Arroyo San
Marcos
Oil on Canvas
96″ x 48″
1979

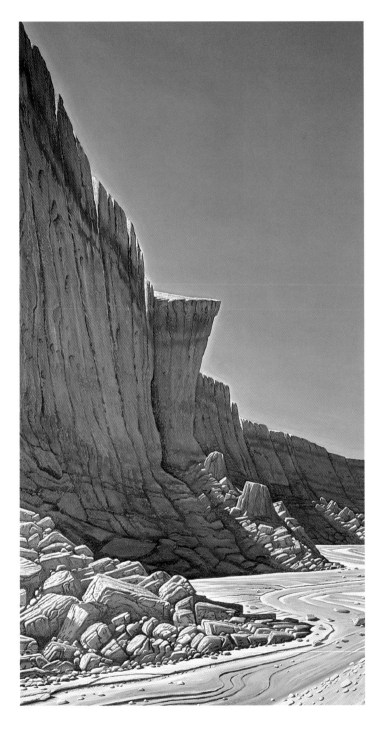

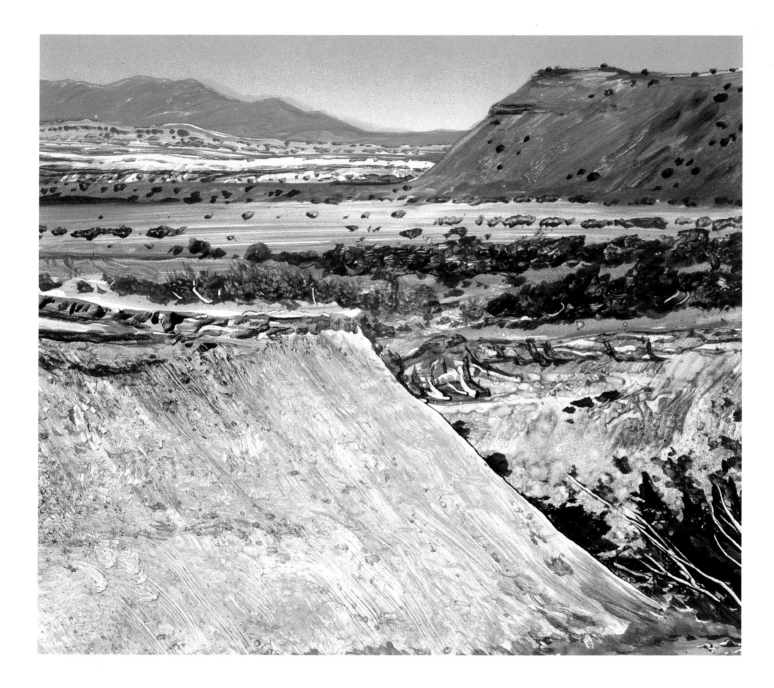

Arroyo Blanco
Monotype
22.75″ x 20.75″
1987

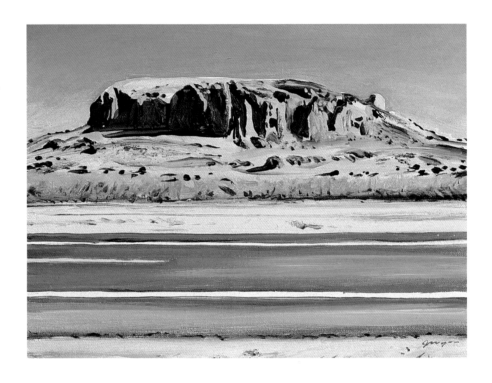

Study for Black Mesa

Oil on canvas

8″ x 12″

1982

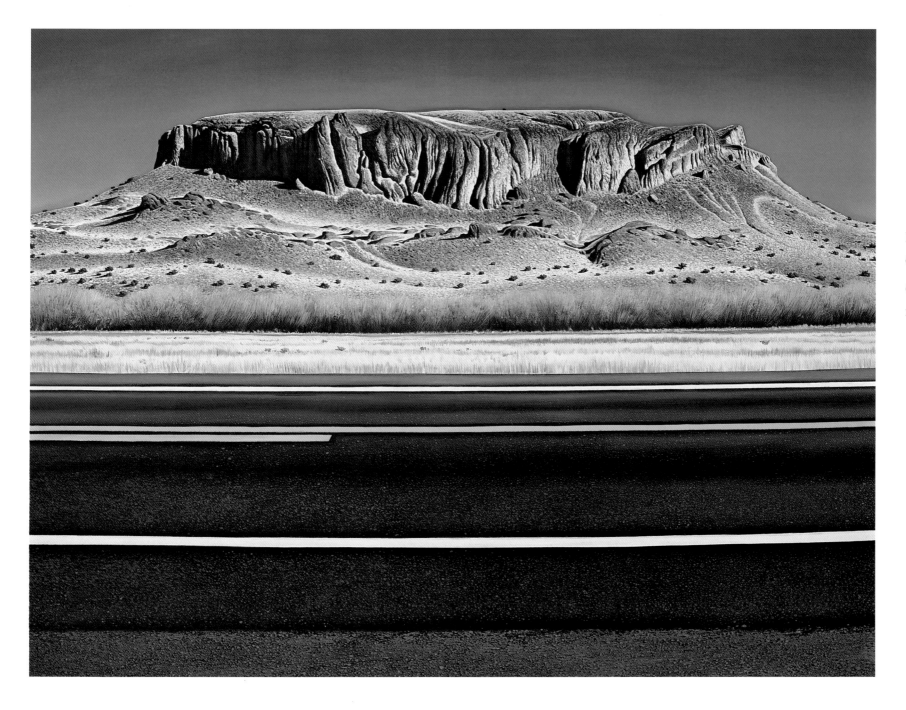

Black Mesa
Oil on canvas
60″ x 90″
1982

Ortiz
Oil on canvas
6″ x 36″
1979

Capitan Peak Study
Sketchbook
Watercolor
Page: 10″ x 12″
1990

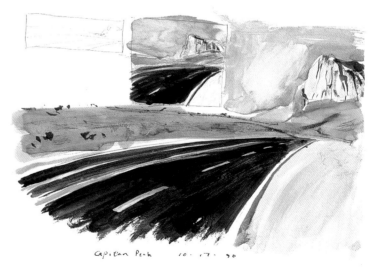

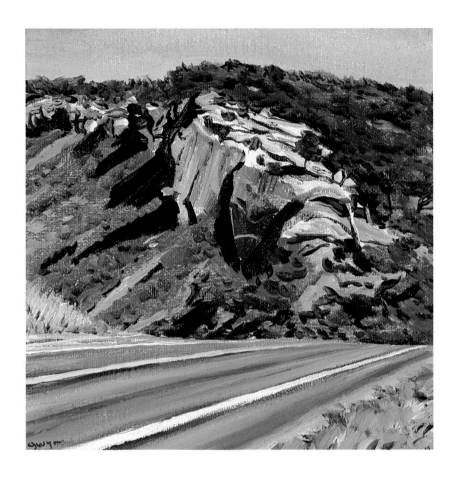

Study for Capitan

Oil on canvas

6″ x 5.75″

1987

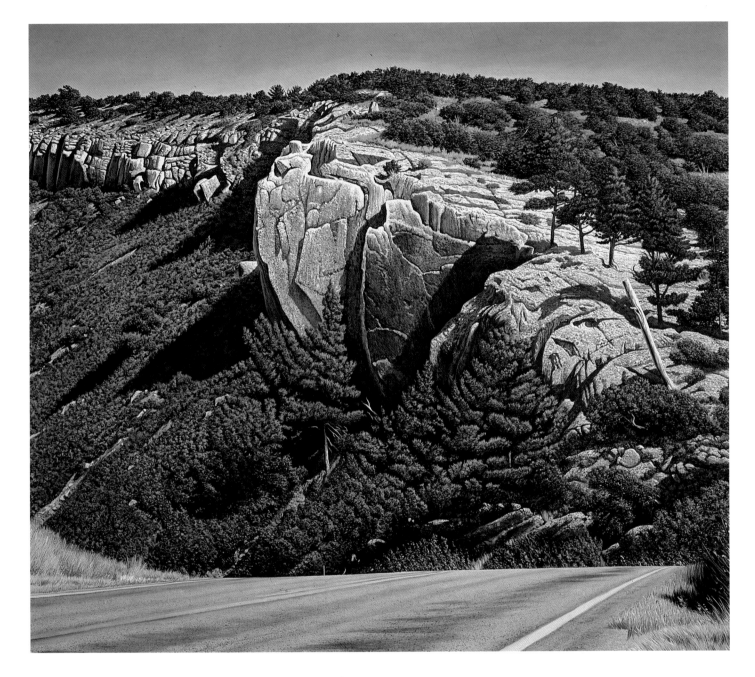

Capitan

Oil on canvas

84″ x 96″

1987-88

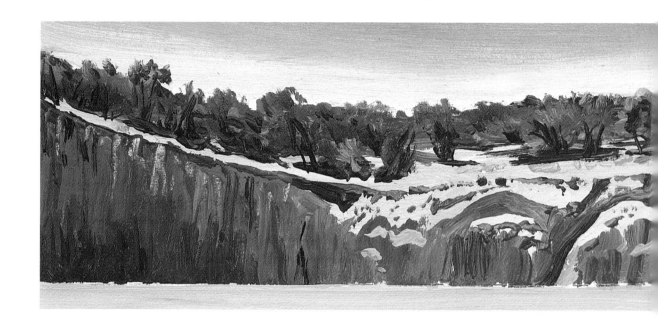

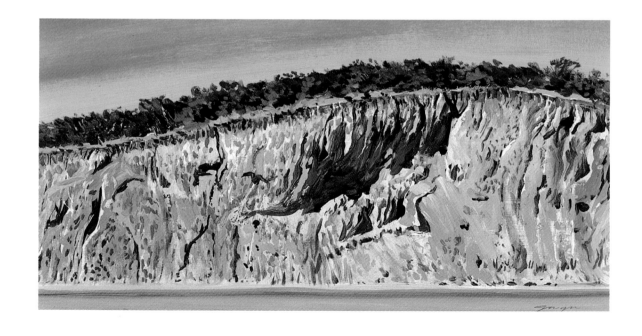

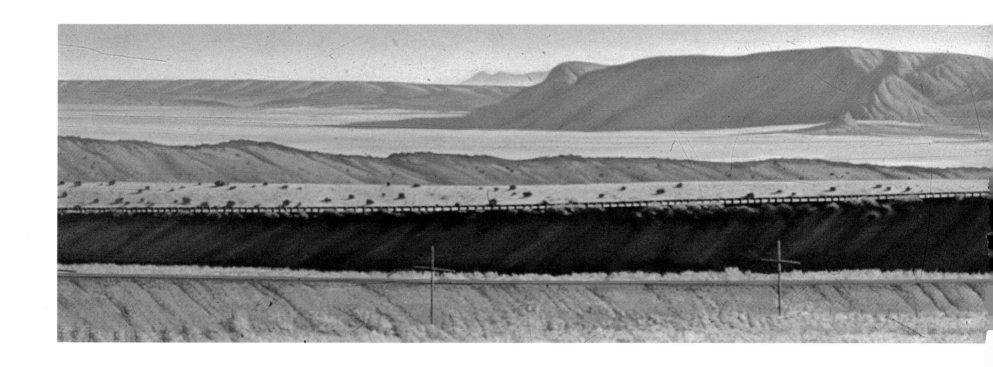

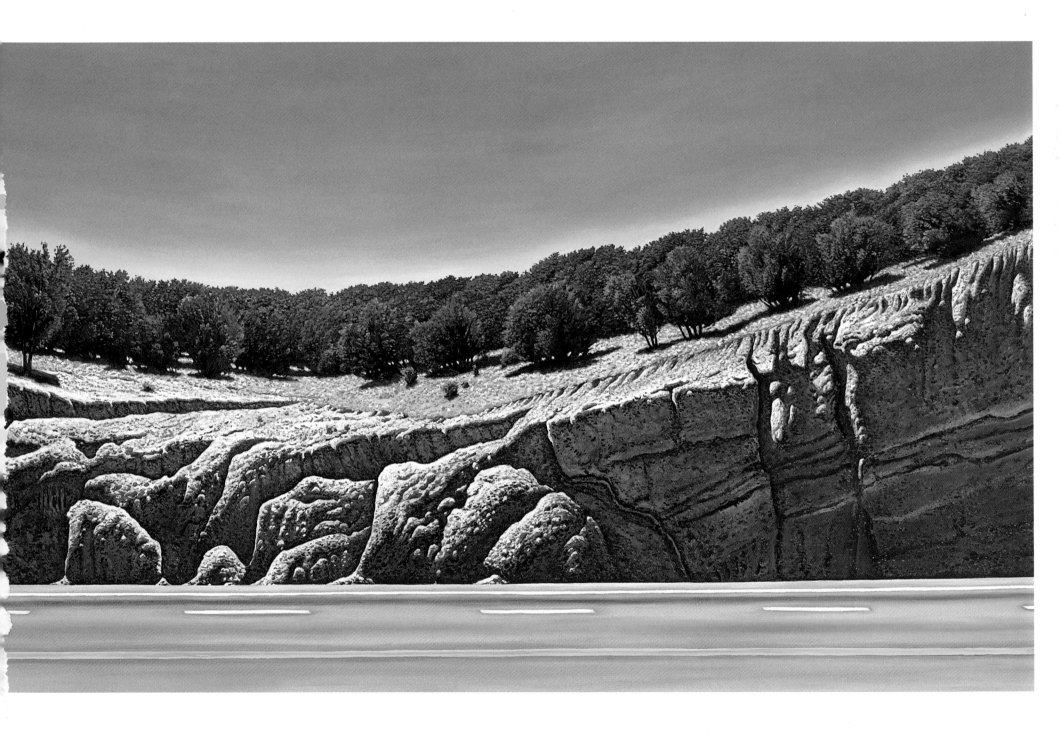

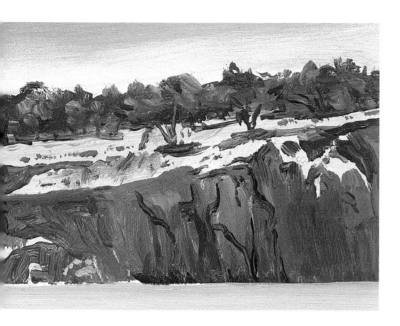

Study for Road Cut II
Oil on paper
3.5" x 11.5"
1985

Study for Road Cut II
Oil on paper
6" x 17"
1985

Road Cut II
Oil on canvas
48" x 108"
1985-86

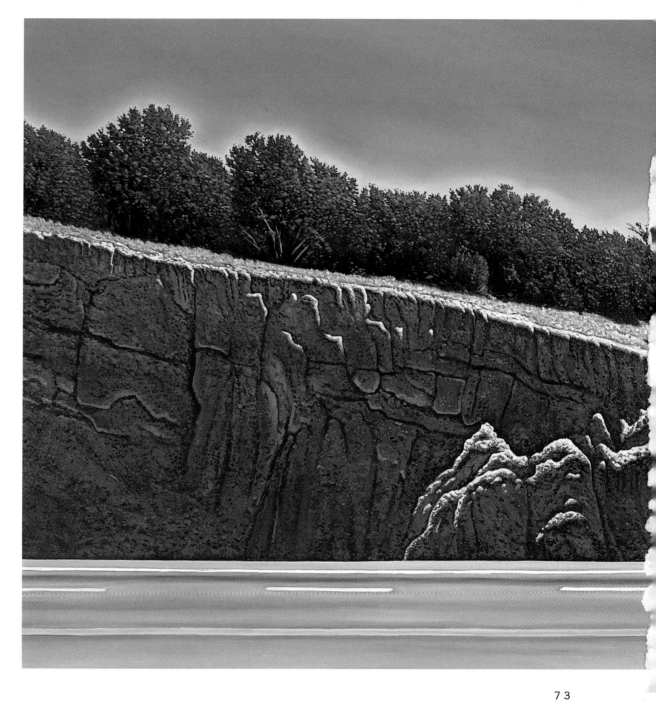

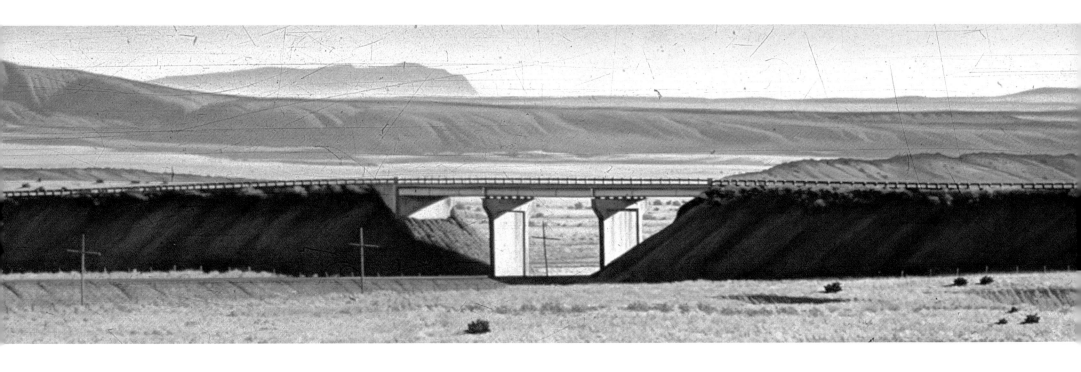

Lamy Bridge
Oil on canvas
24" x 192"
1987-88

Study for Lamy Bridge II
Watercolor
2.5" x 5.5"
1986

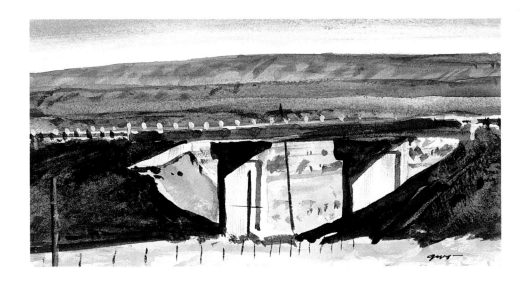

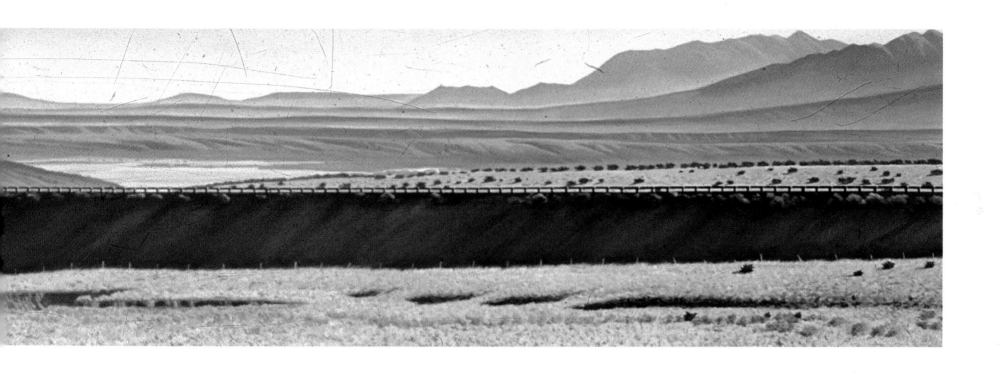

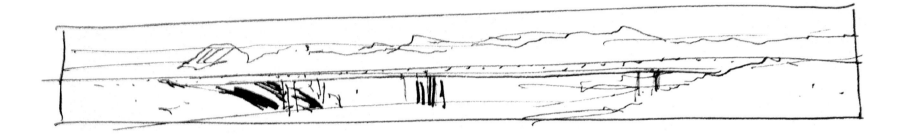

Study for Lamy Bridge

Above: Pen and ink

1.5″ x 8″

Right: Pencil and ink

6″ x 10″

1986

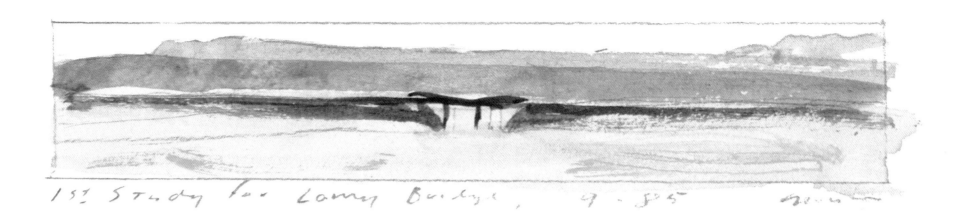

1st Study for Canoy Bridge, 9-85 [signature]

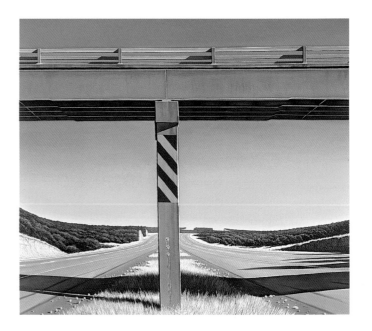

Overpass II
Oil on canvas
24″ x 84″
1982

Overpass I
Oil on canvas
84″ x 96″
1982

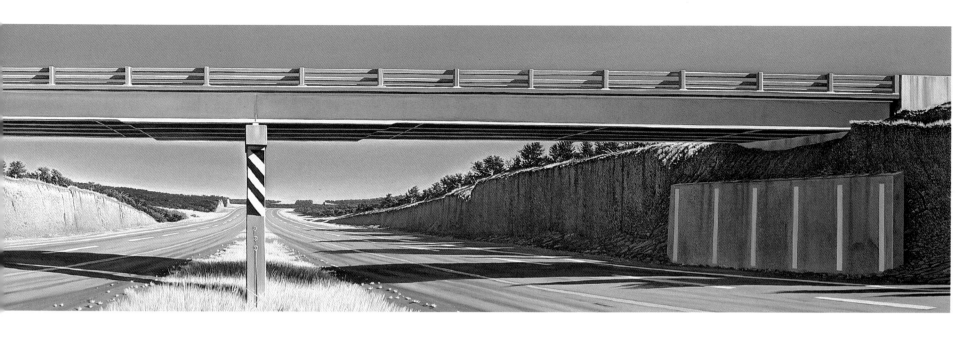

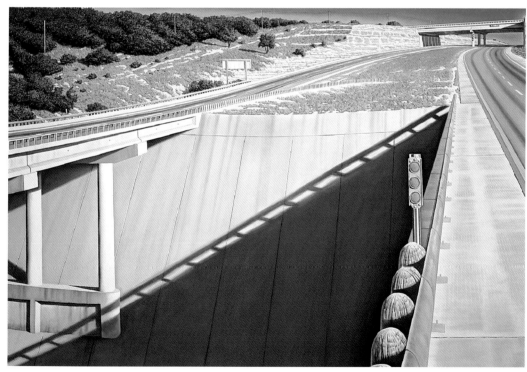

Texas Overpass

Oil on canvas

48″ x 72″

1985

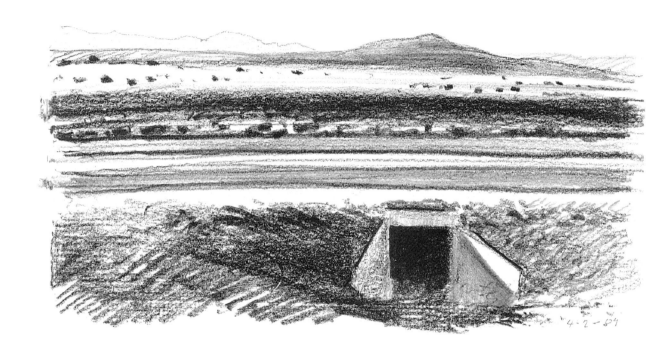

Paul's Culvert
Sketchbook
Graphite on paper
5″ x 9″
1988

Paul's Culvert
Oil on wood panel
10″ x 12″
1990

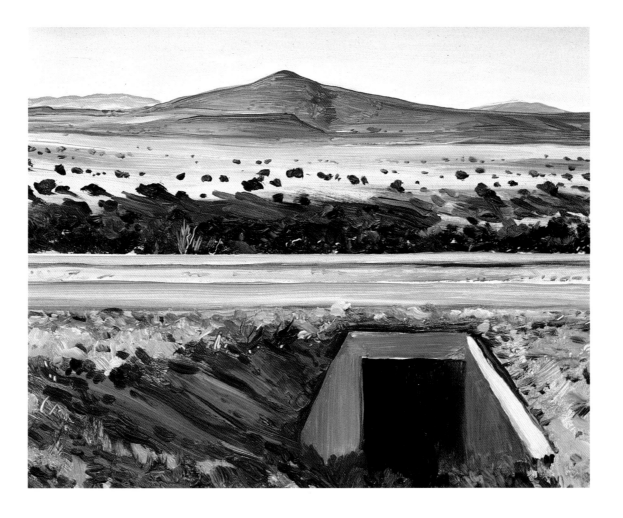

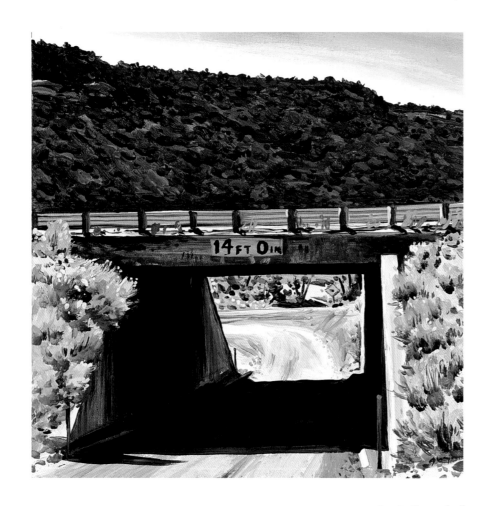

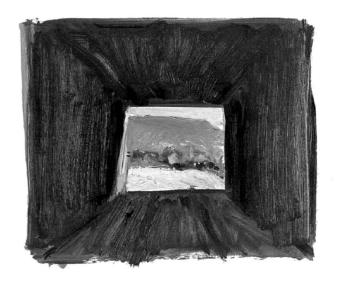

Study for Tunnel
Oil on paper
12″ x 16″
1982

Study for 14′ 0″
Oil on canvas
10″ x 10″
1982

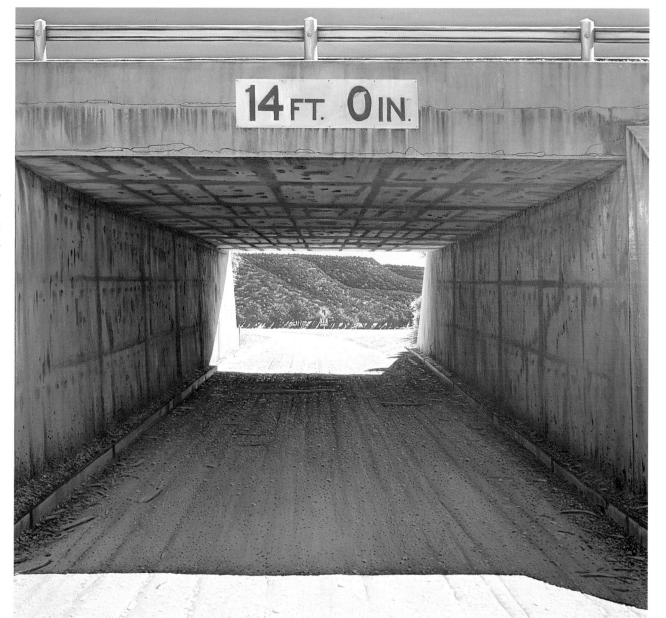

14′ 0″
Oil on canvas
48″ x 54″
1982

Subway
Oil on canvas
48″ x 12″
1984

Tunnel
Oil on canvas
48″ x 48″
1982

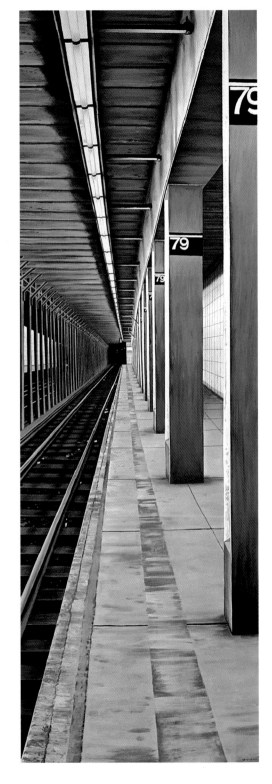

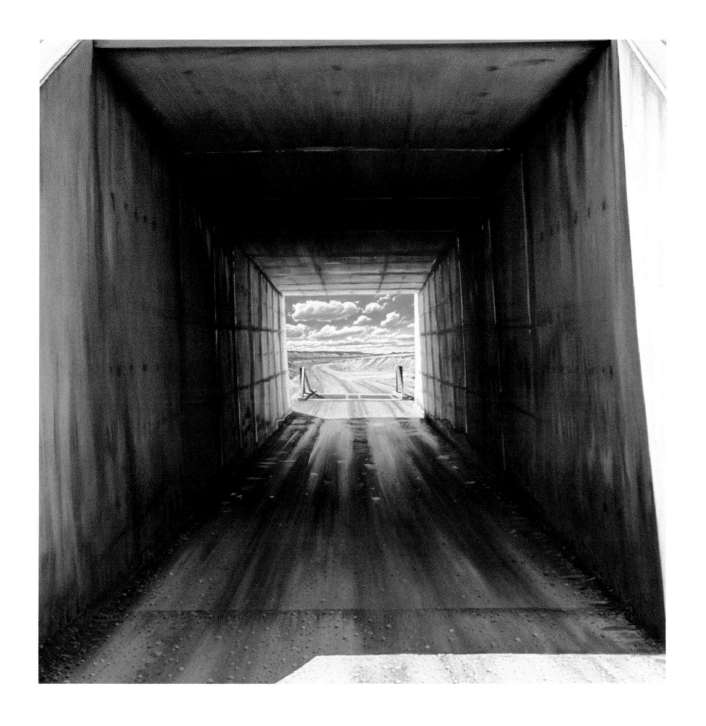

Two-Lane Road Studies

Sketchbook

Watercolor

3″ x 6″

1986

Pen and ink

4″ x 16″

1990

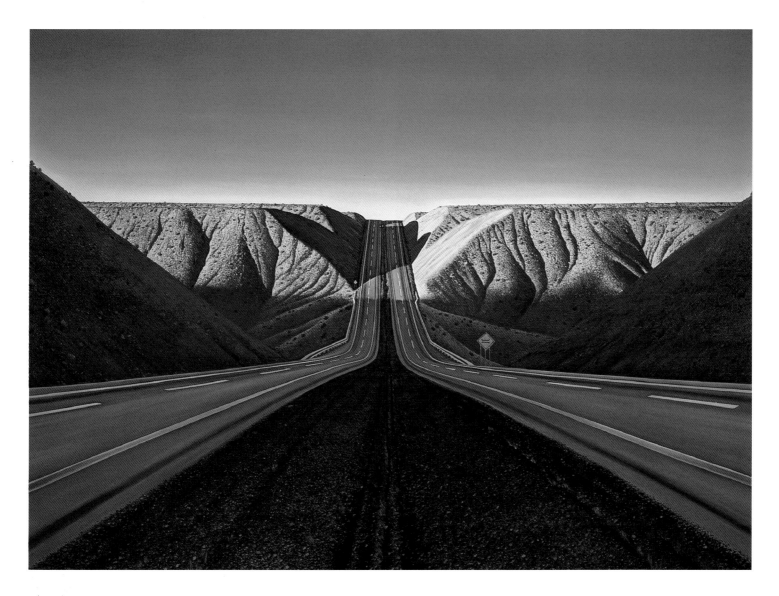

Two-Lane Road Cut

Oil on canvas

48″ x 84″

1986

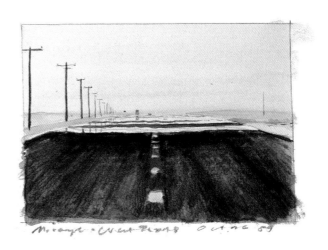

Mirages
Sketchbook
Mixed media
12″ x 18″
1989

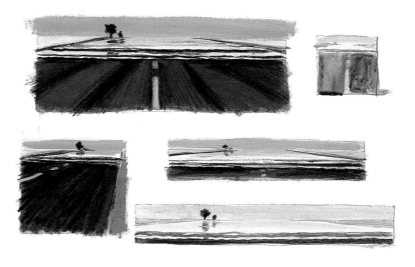

Mirages Studies
Sketchbook
Watercolor
6″ x 18″
1989

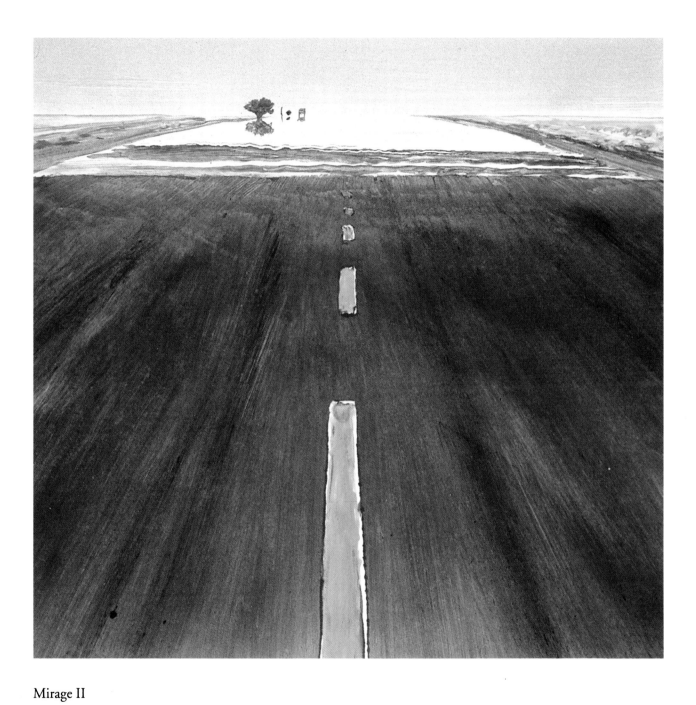

Mirage II

Monotype

12″ x 12″

1990

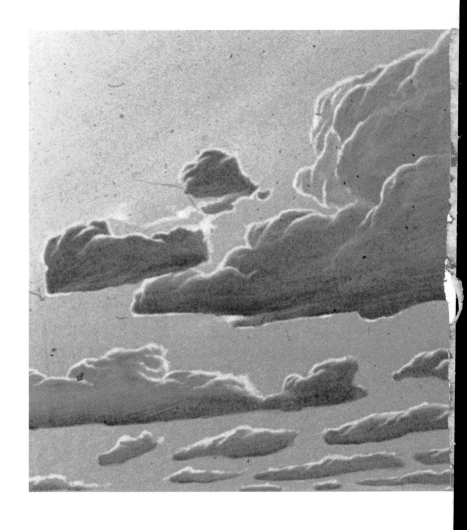

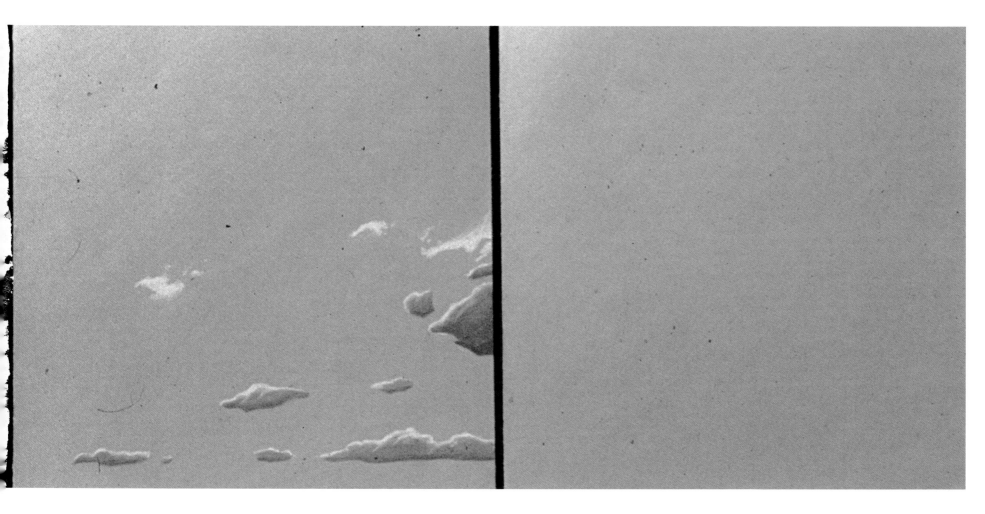

Cloud Progression

Acrylic

8″ x 32″

1973

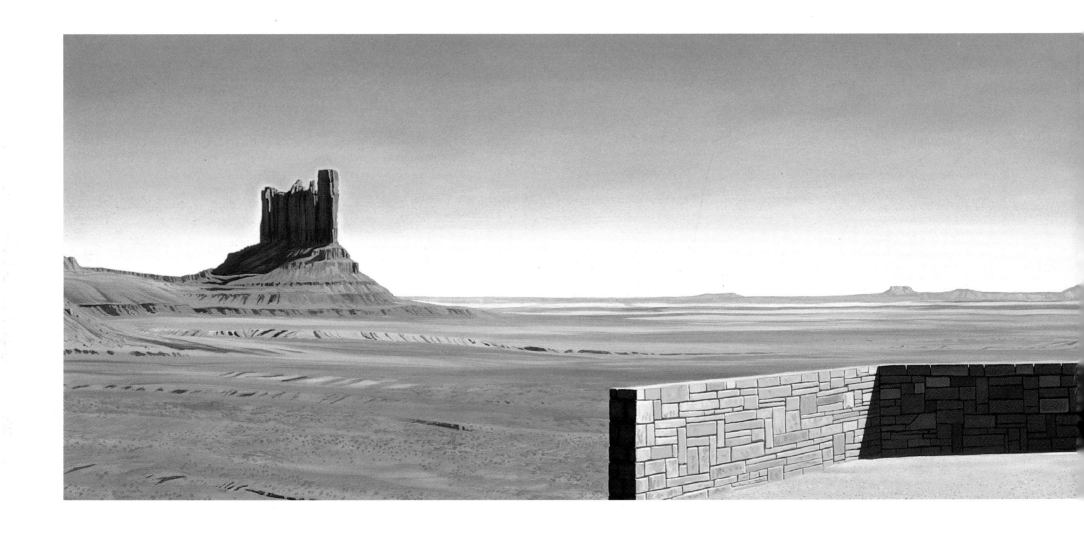

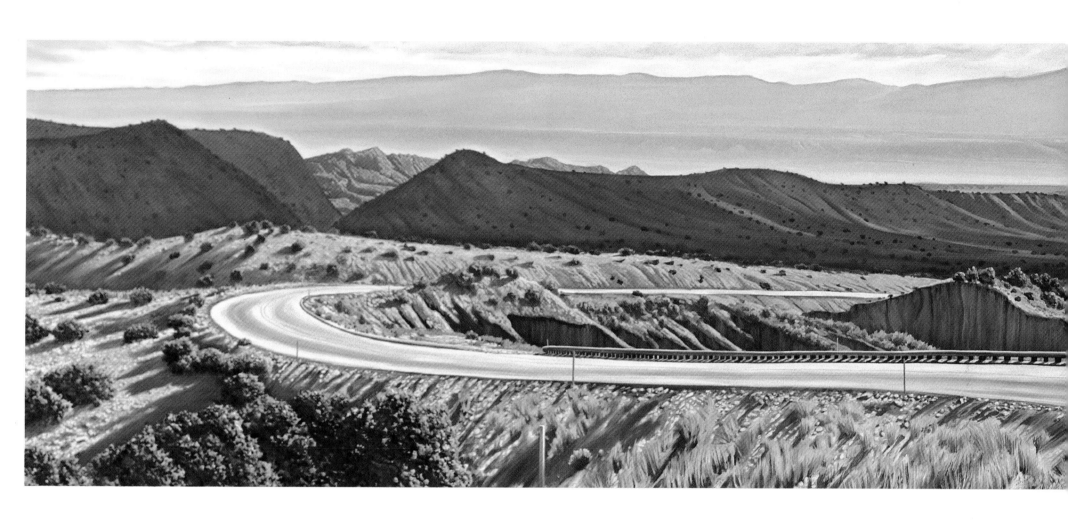

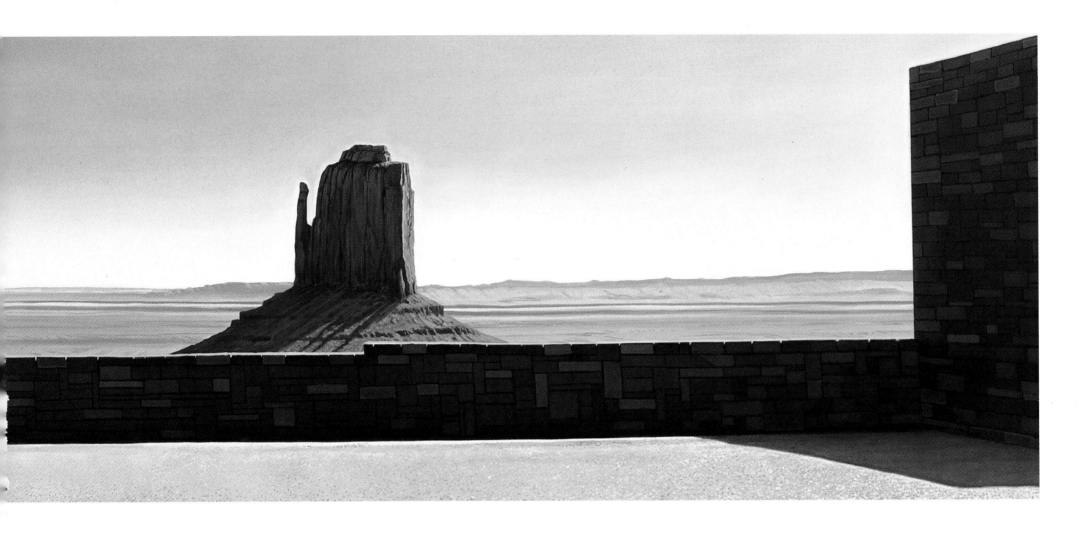

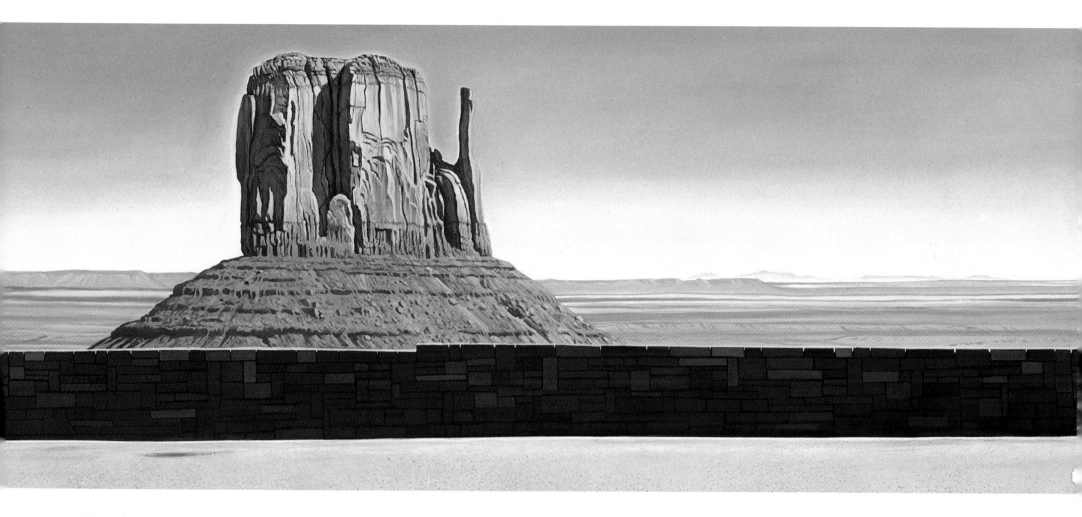

Visitor's Center

Oil on canvas

24" x 168"

1992

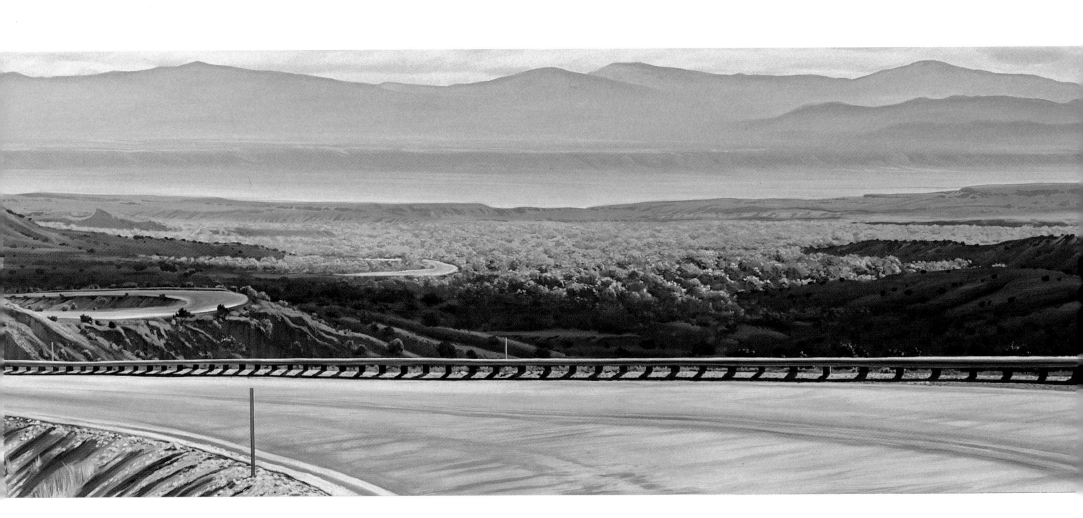

Chimayo I

Oil on canvas

24″ x 180″

1991-92

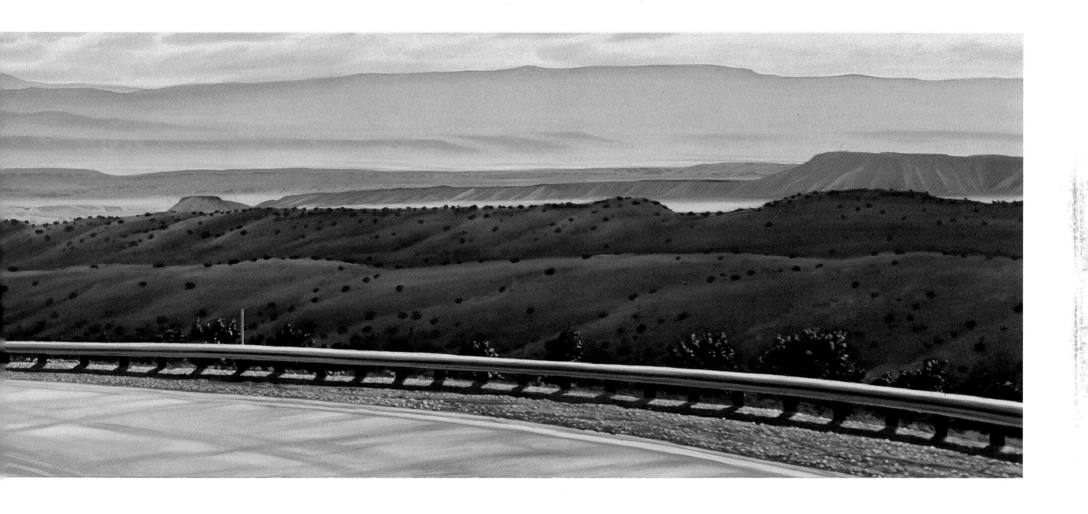

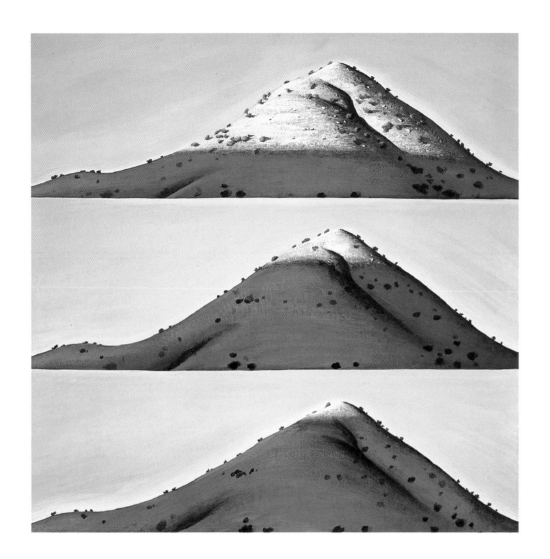

Dawn Ascension

Acrylic

36″ x 36″

1976

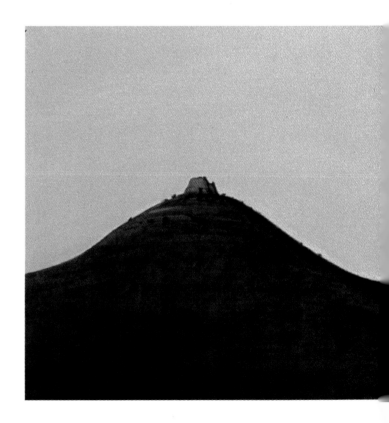

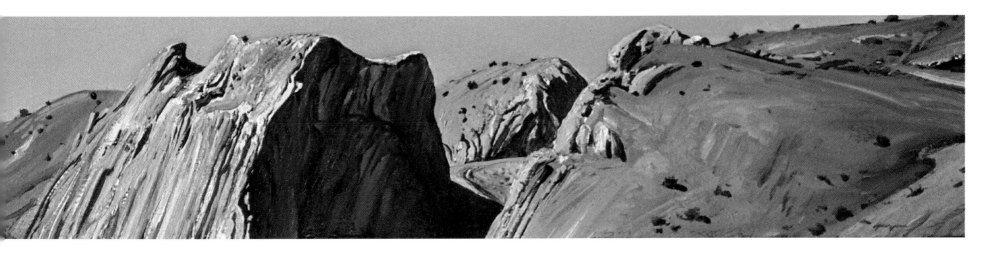

Devil's Throne
Oil on canvas
3″ x 18″
1981

Dawn Progression
Acrylic
8″ x 32″
1973

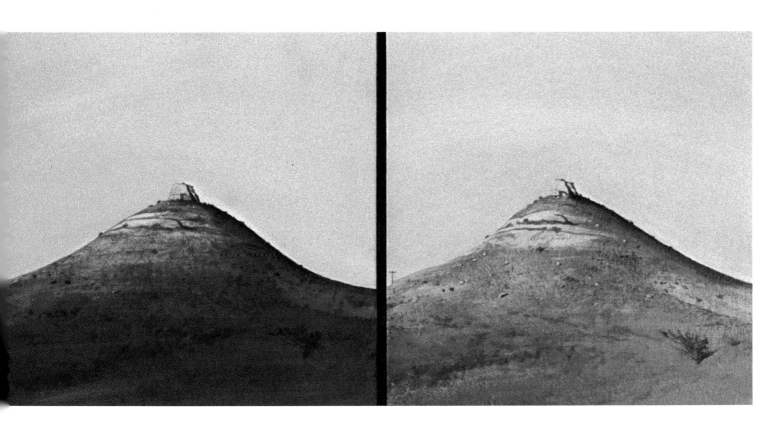

Foothill Study
Oil on canvas
8″ x 12″
1982

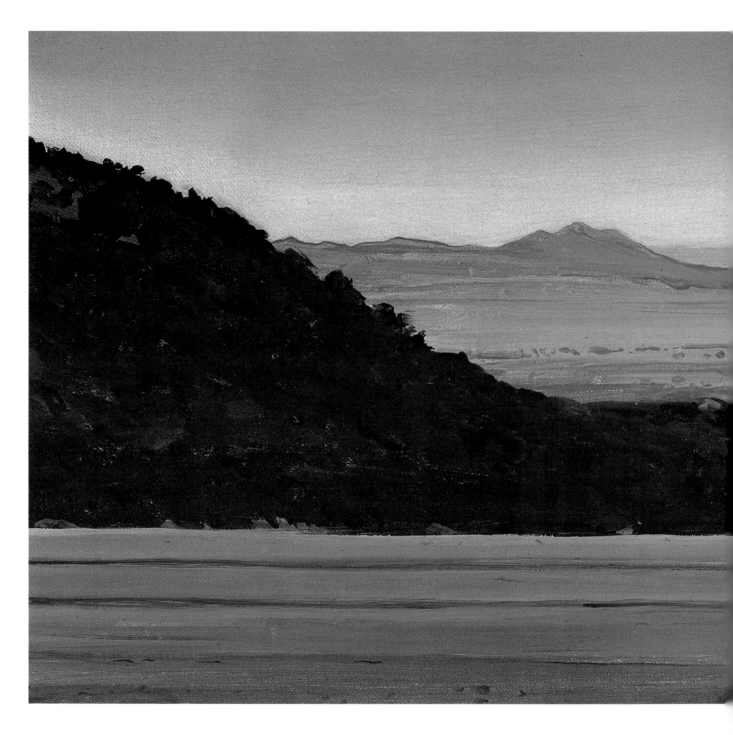

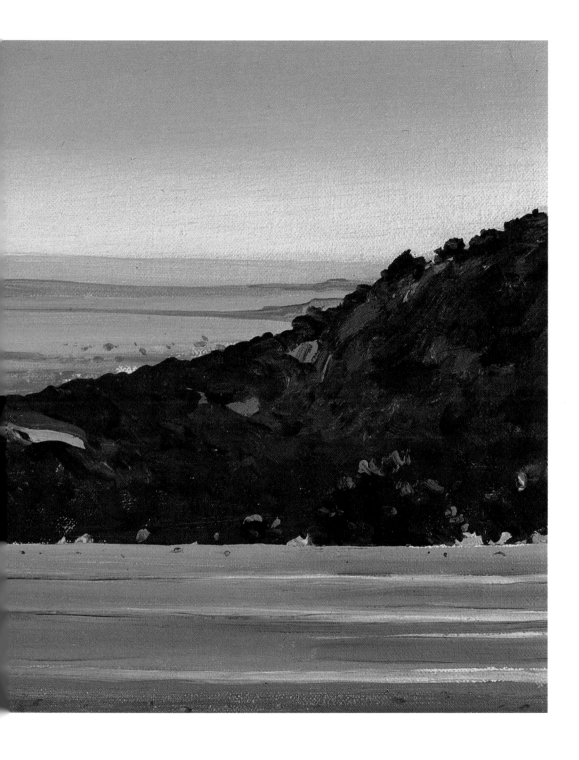

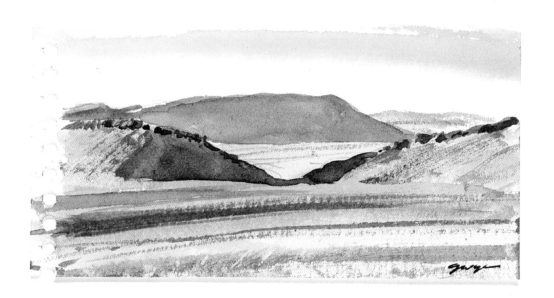

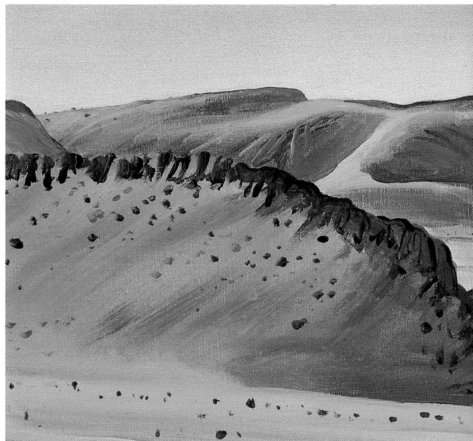

Comanche Gap
Study
Watercolor
2″ x 4″
1986

Comanche Gap
Study
Oil on canvas
9″ x 20″
1986

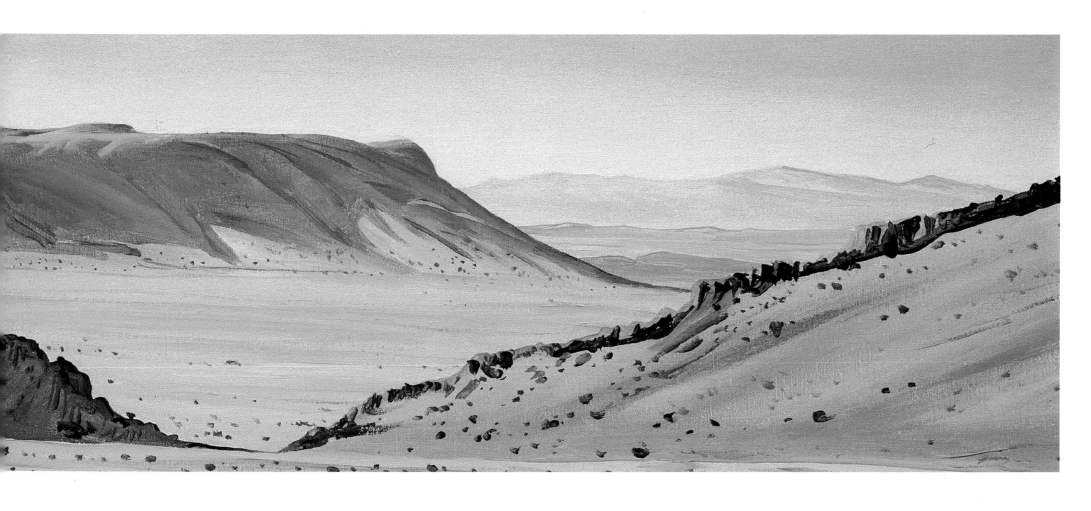

Ski Basin Curve

Sketchbook

Graphite on paper

3″ x 5″

1988

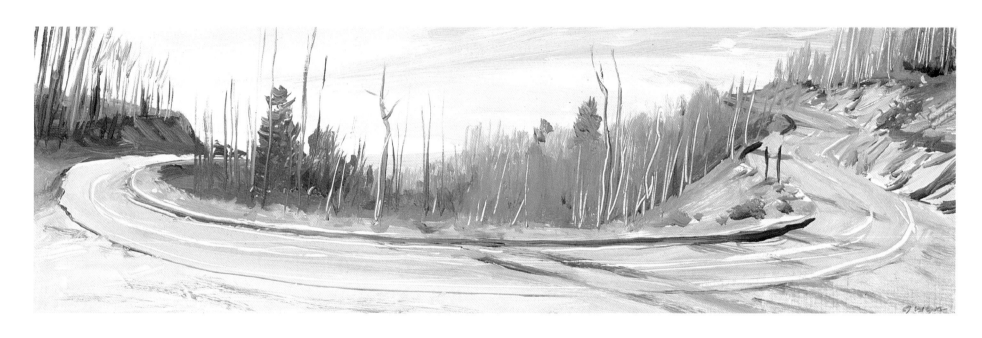

Ski Basin Curve

Oil on wood panel

3″ x 9″

1989

Ski Basin Road
Oil on canvas
12″ x 36″
1989

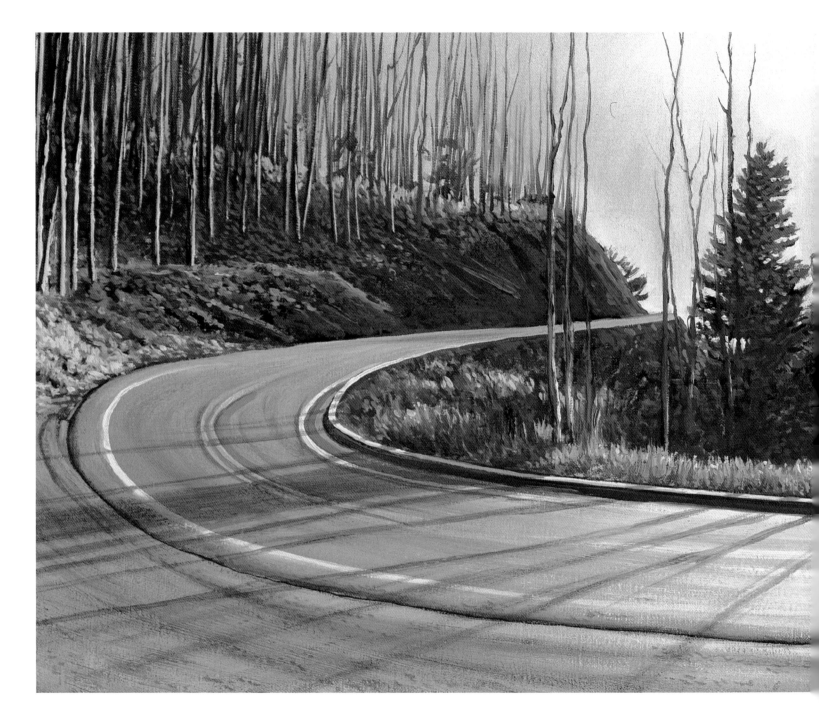

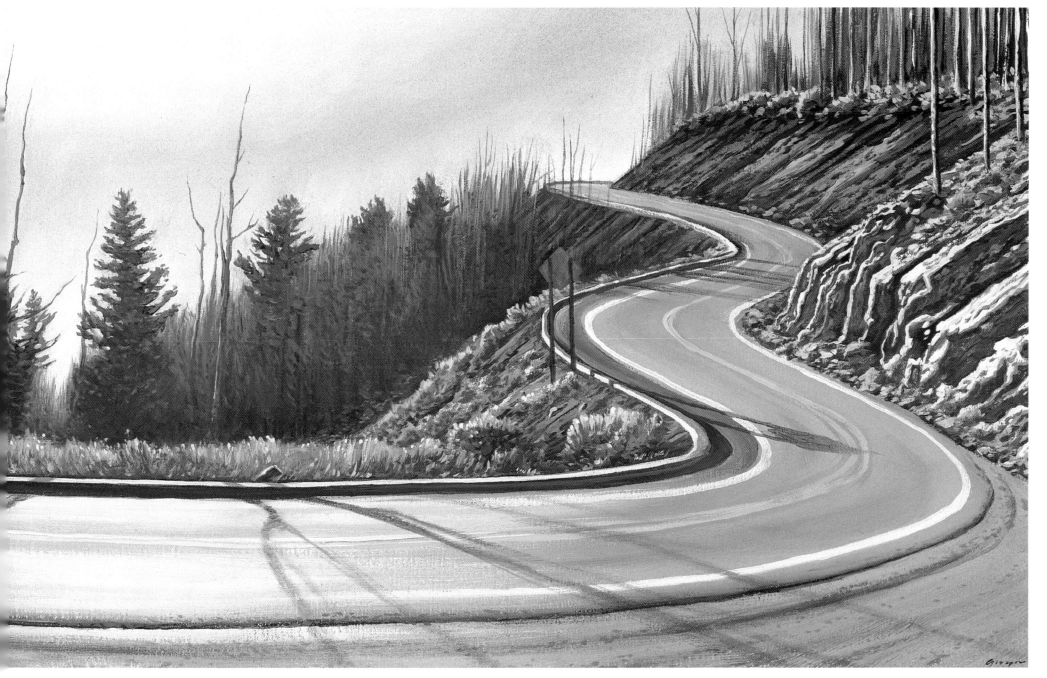

Curve

Oil on canvas

60" x 144"

1992-93

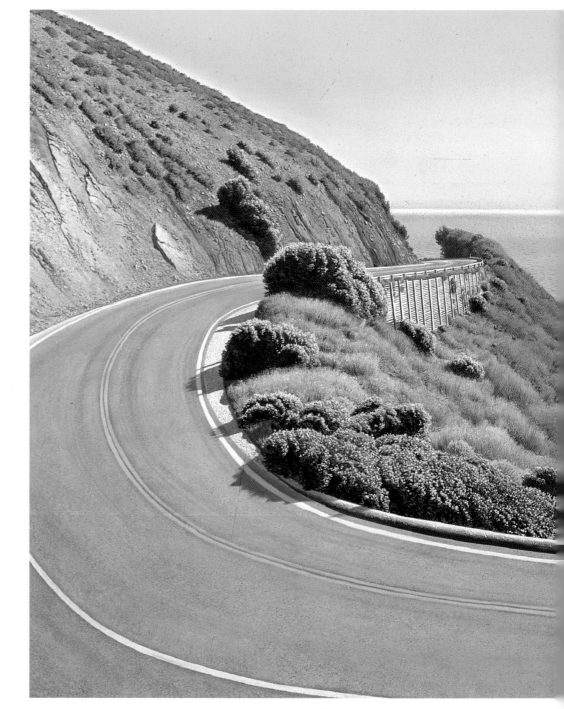

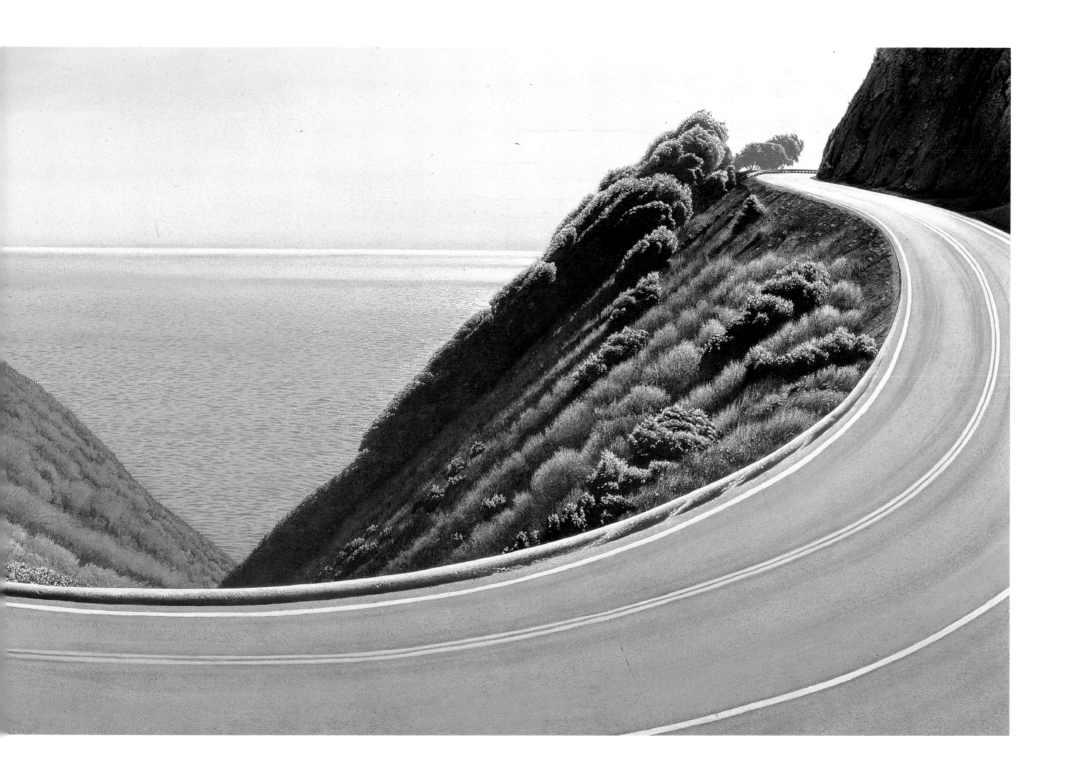

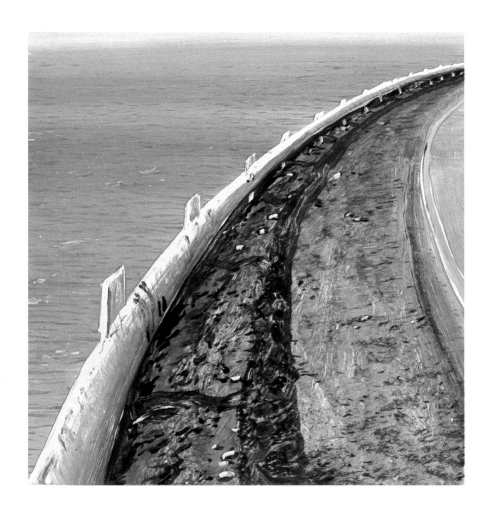

Guardrail/Ocean
Sketchbook
Graphite on paper
Various sizes
1983

Guardrail/Ocean
Monotype
5.75″ x 5.5″
1989

Guardrail/Ocean
Egg tempera on wood panel
12″ x 12″
1985

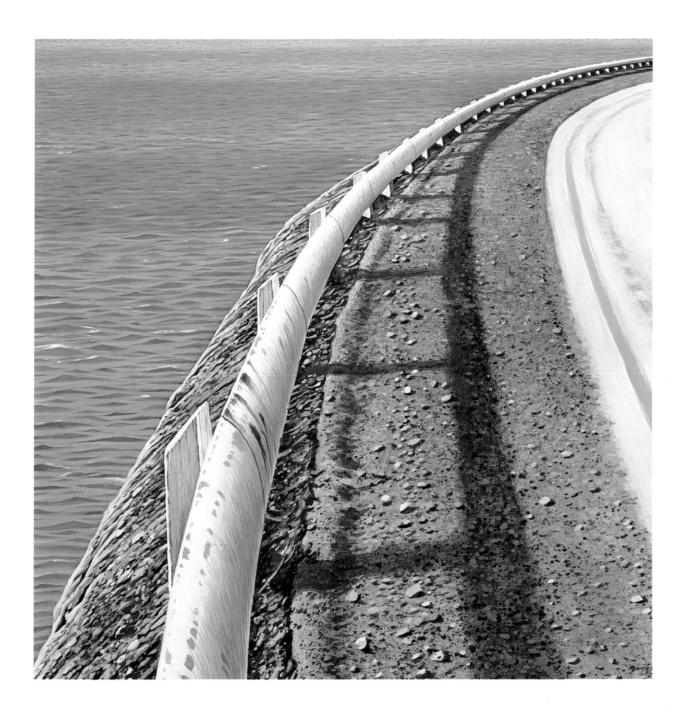

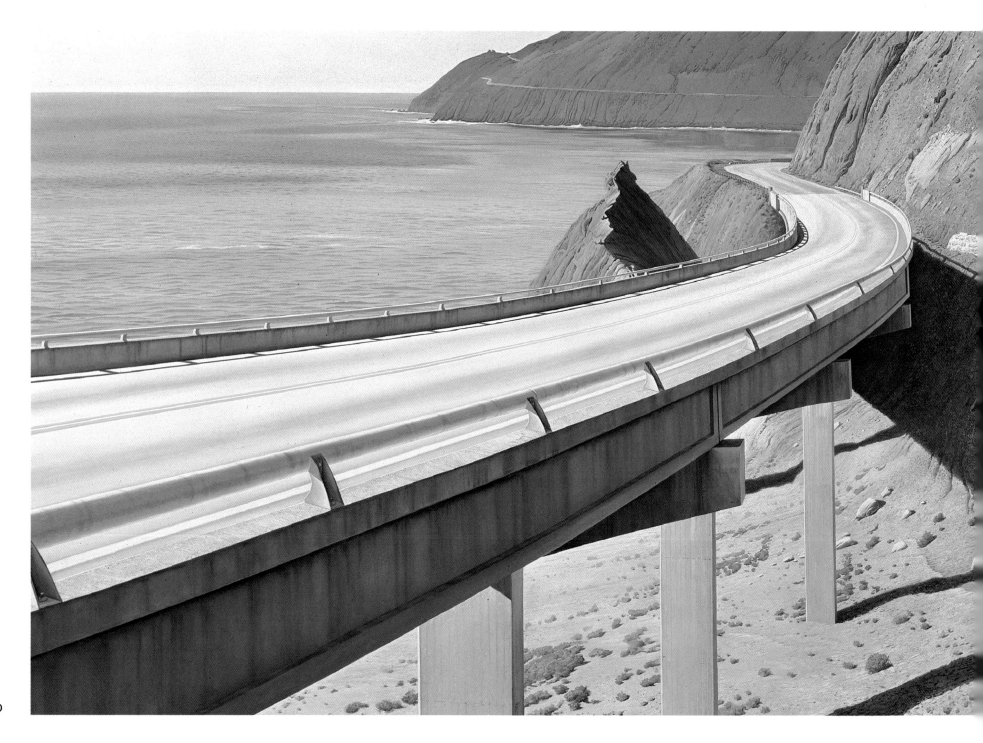

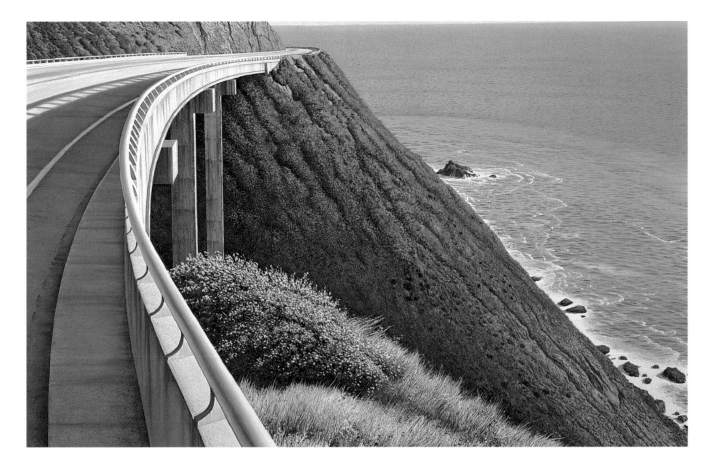

Bridge II
Oil on canvas
44″ x 70″
1992-93

Bridge I
Oil on canvas
54″ x 108″
1992-93

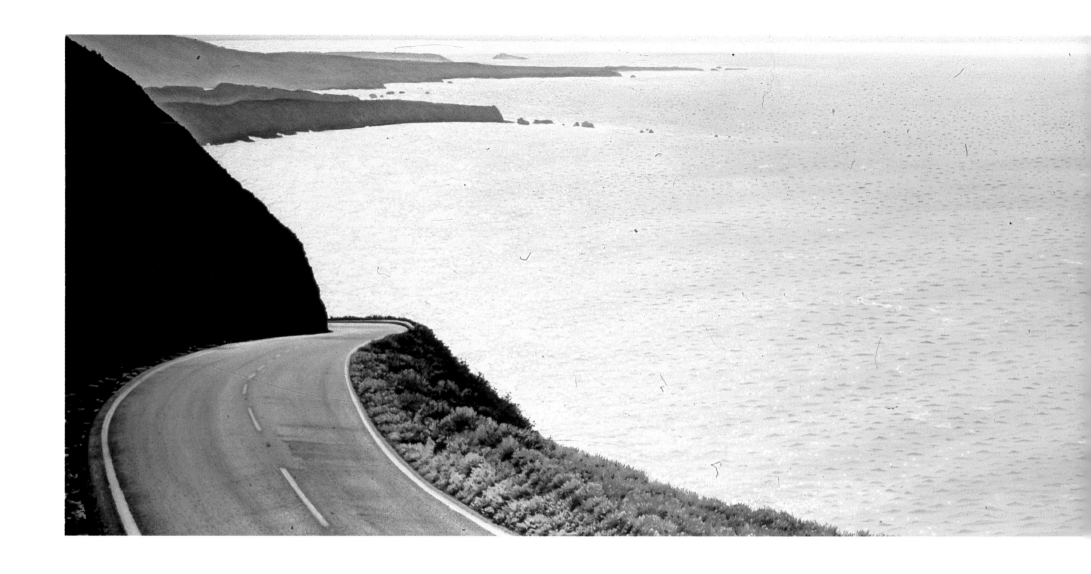

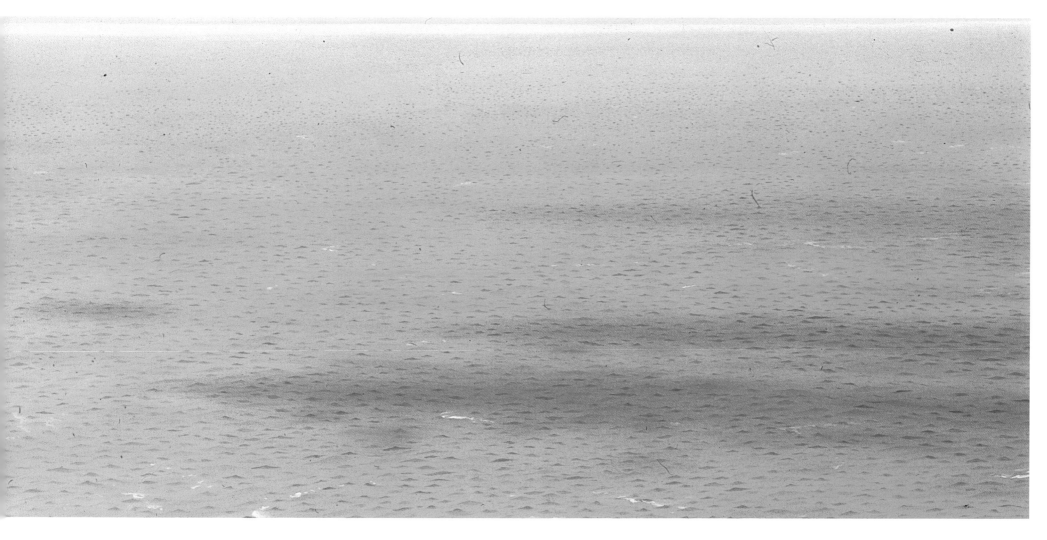

Coast Highway

Oil on canvas

25" x 108"

1990

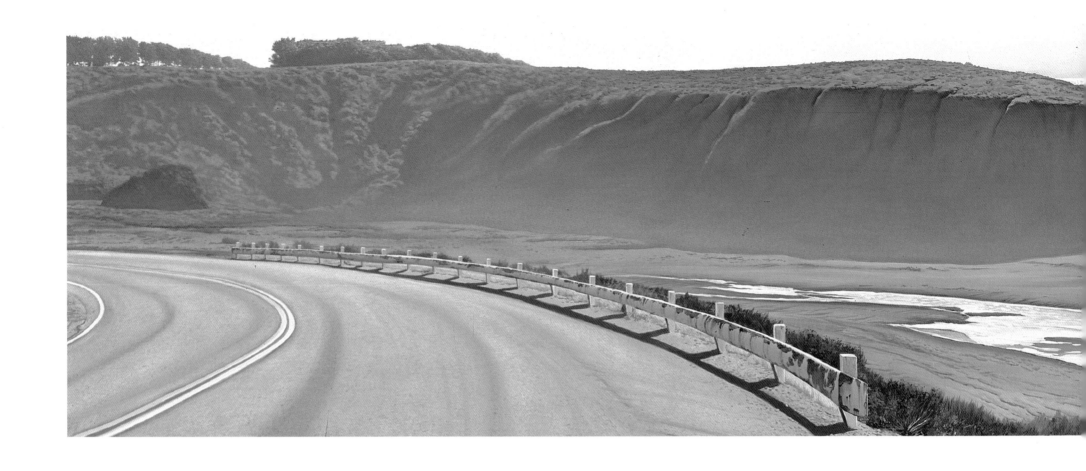

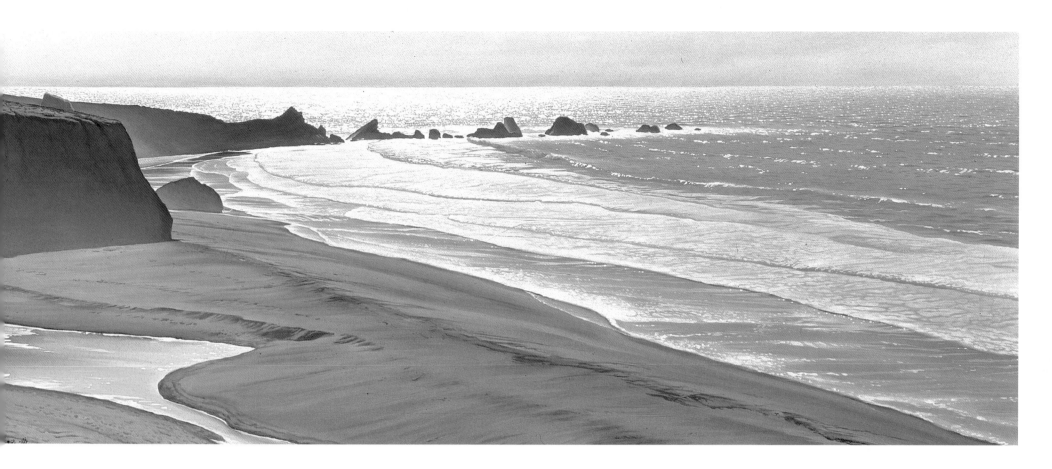

Cove

Oil on canvas

24″ x 126″

1992-93

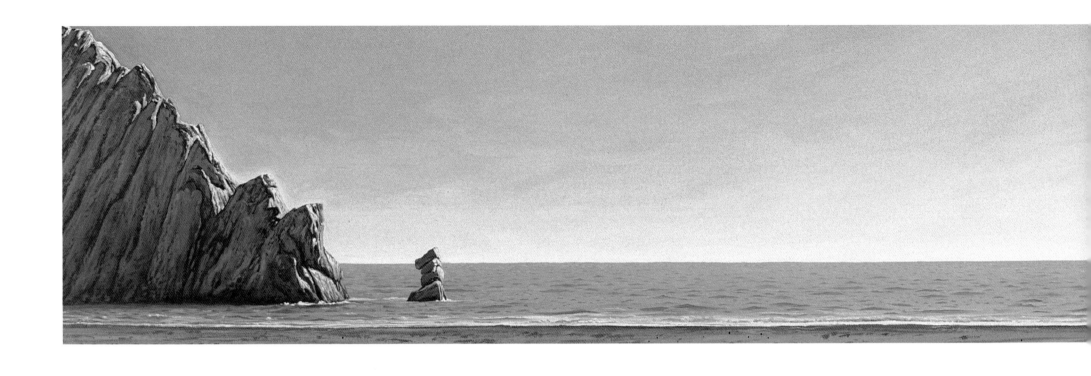

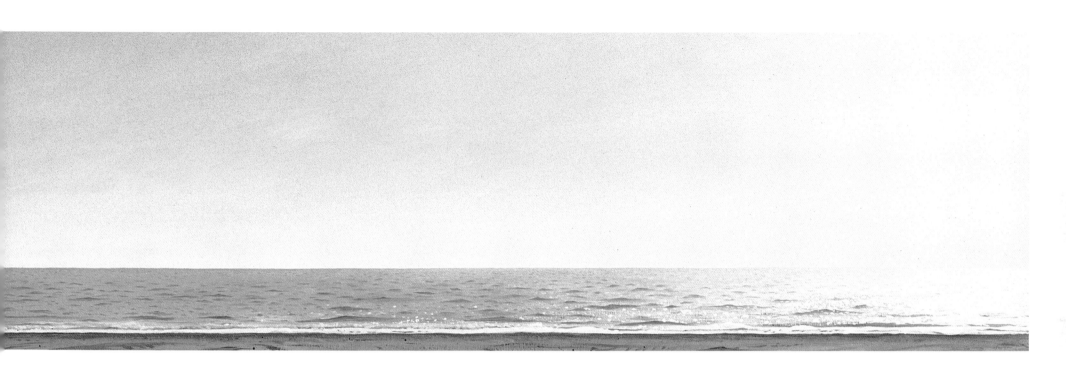

Morro Bay I

Oil on linen

12″ x 84″

1990-91

San Gregorio

Sketchbook

Watercolor

12″ x 16″

1990

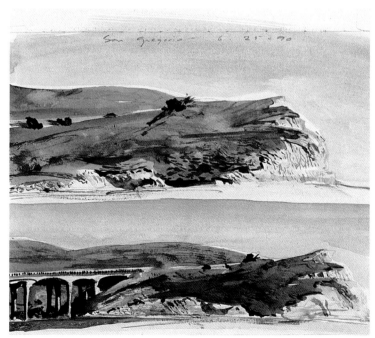

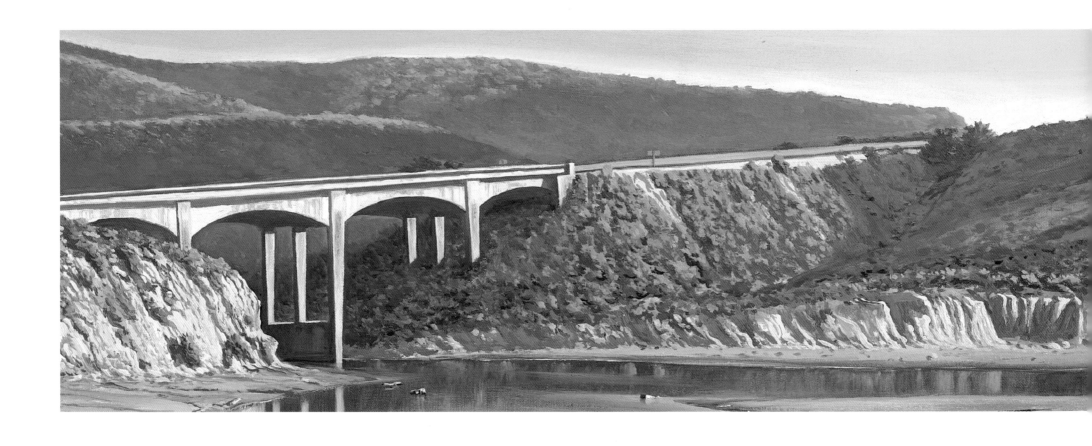

118

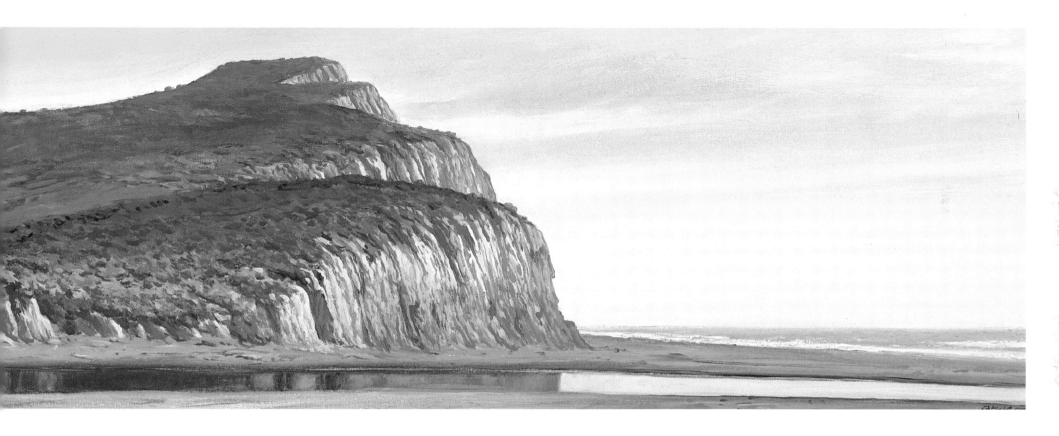

San Gregorio

Oil on canvas

8″ x 46″

1991-92

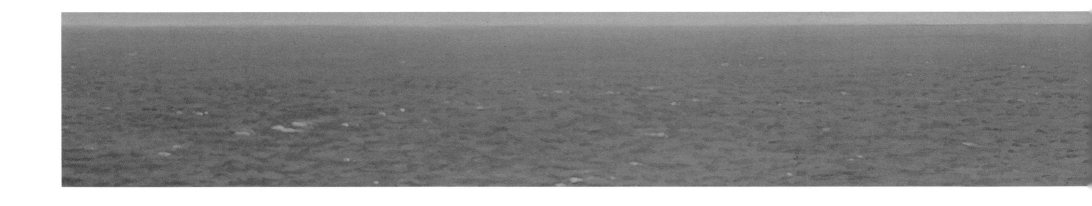

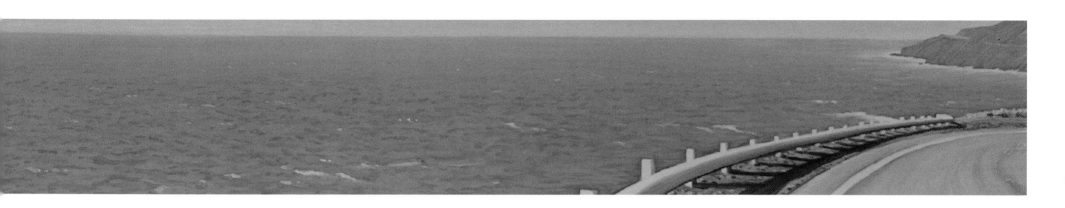

Big Sur Horizon
Egg tempera on
wood panel
3″ x 36″
1989-90

Big Sur Notes
Sketchbook
Colored ink and pencil
18″ x 12″
1989

Big Sur Notes
Sketchbook
Colored ink and pencil
18″ x 12″
1989

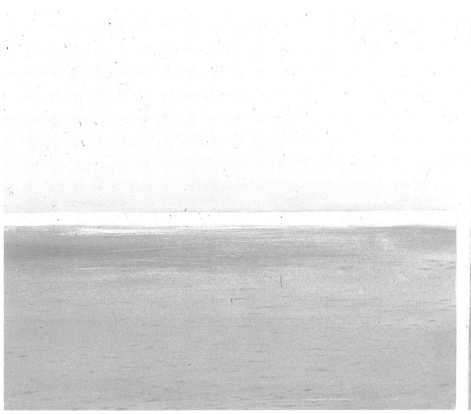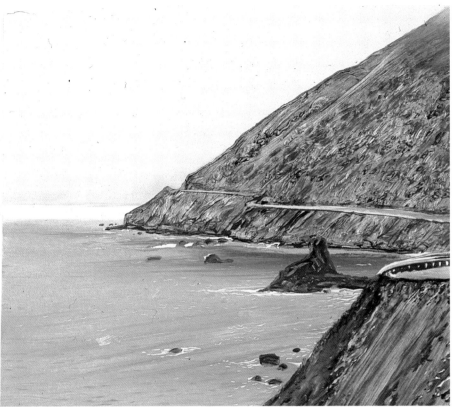

Morning Light—
Big Sur
Monotype
28″ x 41″
1990

Big Sur Notes
Sketchbook
Mixed media
18″ x 12″
1989

Big Sur—Diptych

Oil on canvas

36″ x 96.5″

1990

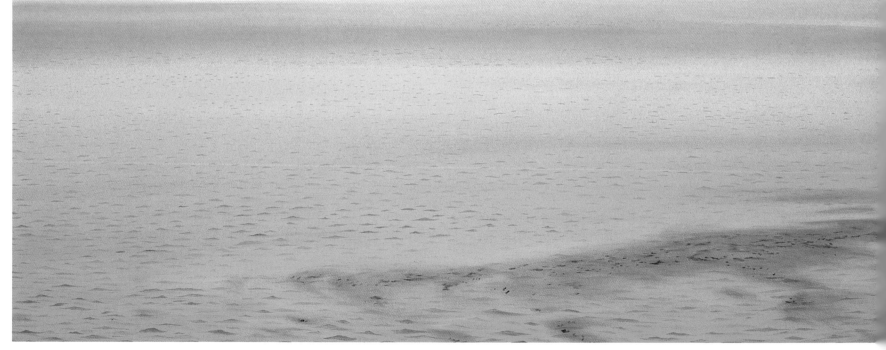

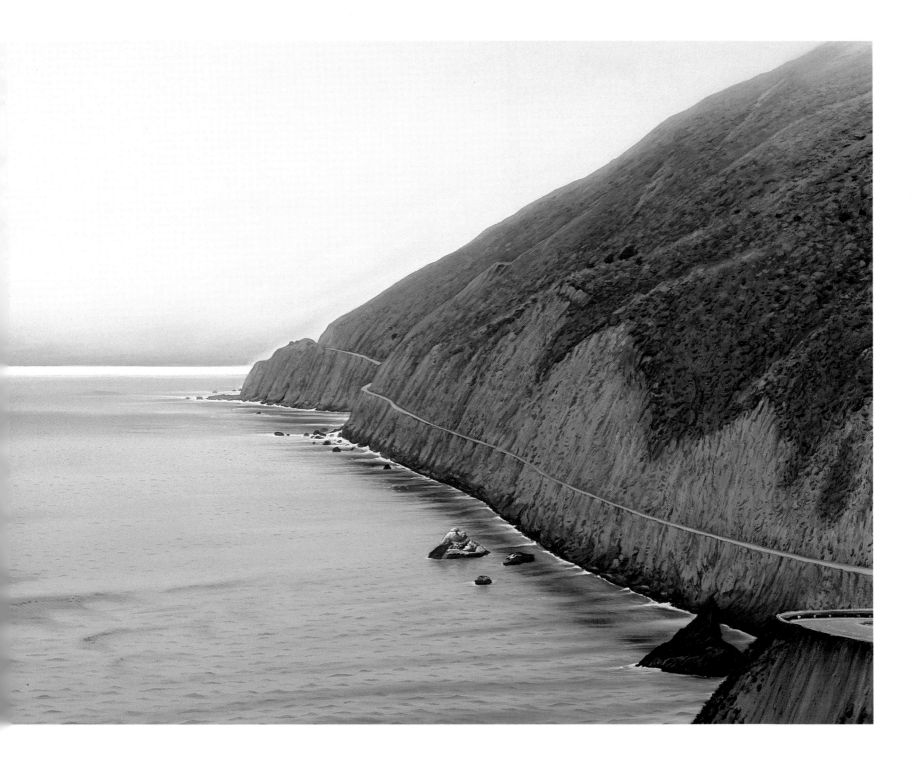

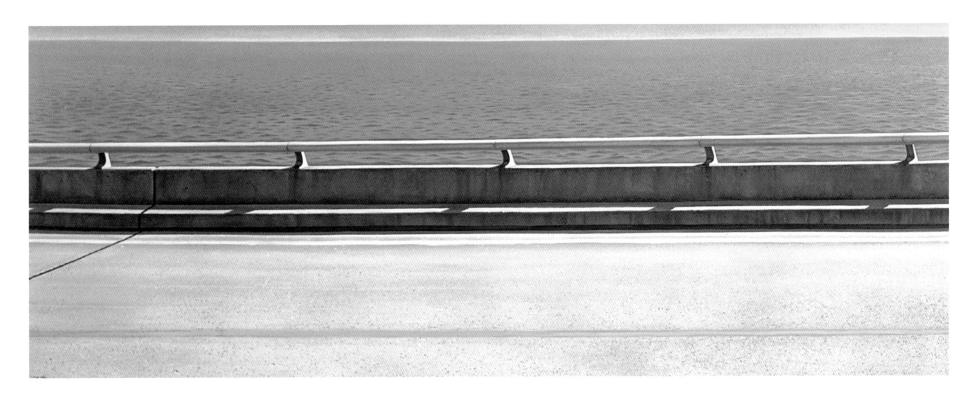

Ocean/Bridge
Oil on canvas
24″ x 78″
1983

126

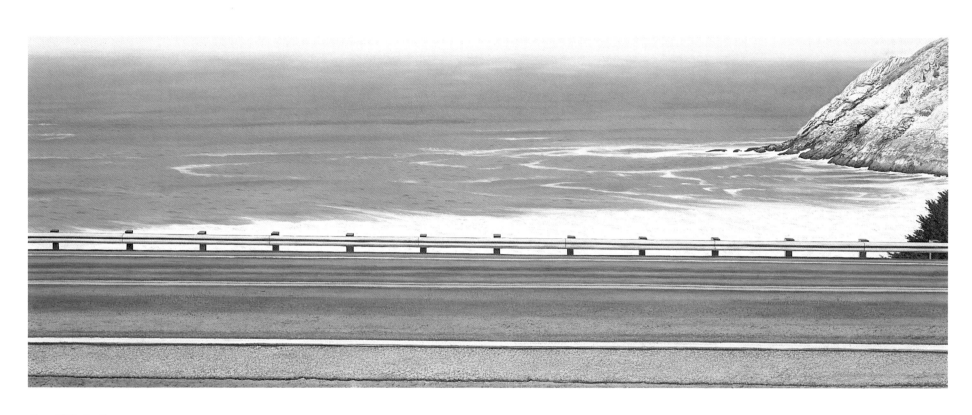

Gray Whale Cove

Oil on wood panel

30″ x 80″

1990-91

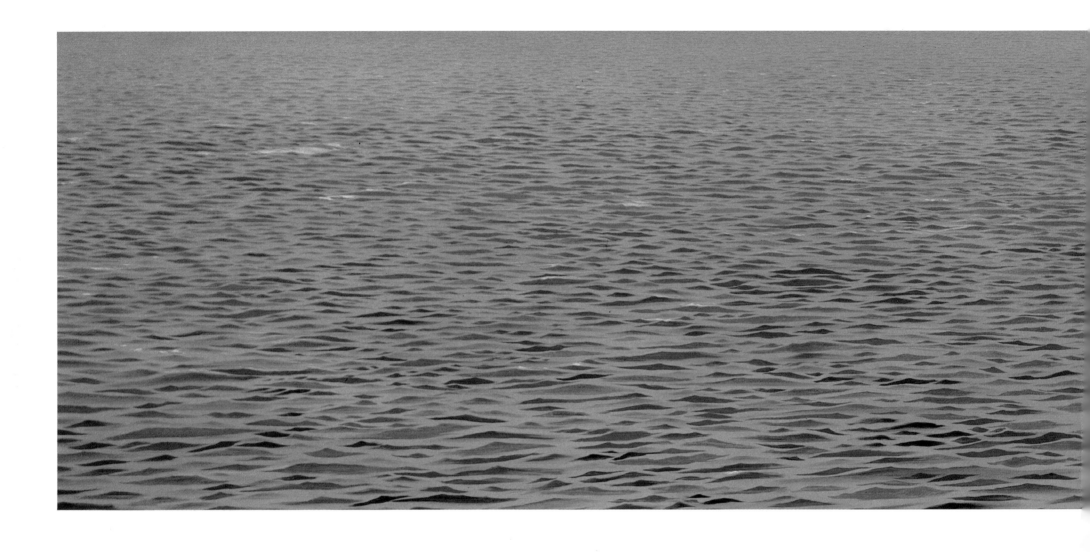

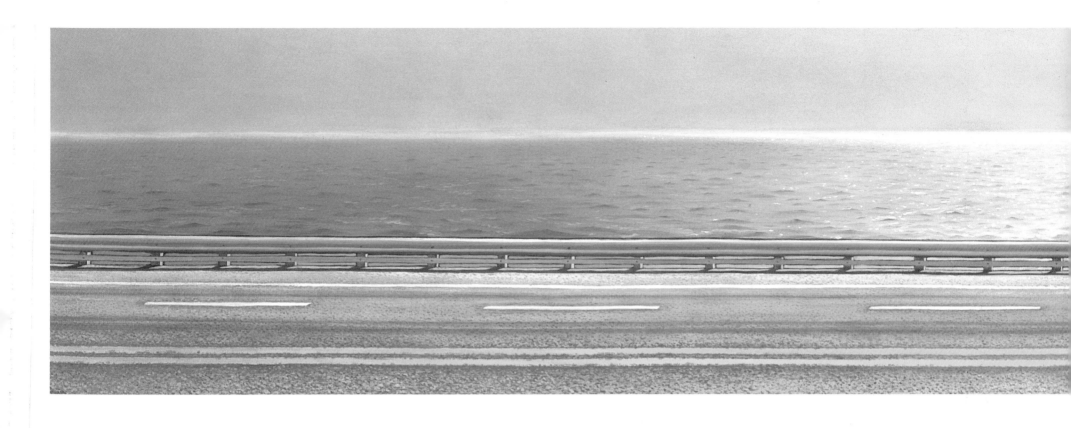

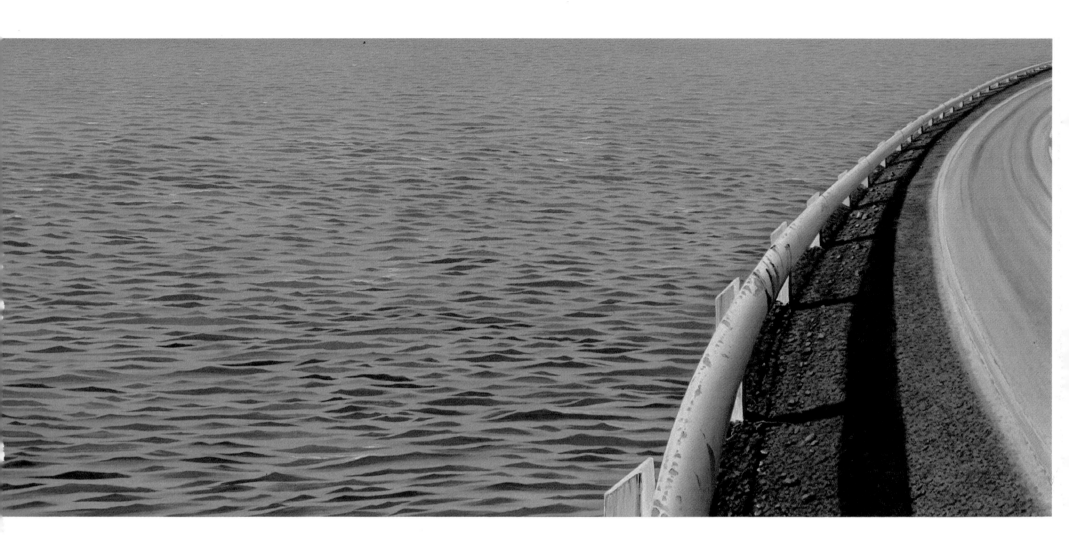

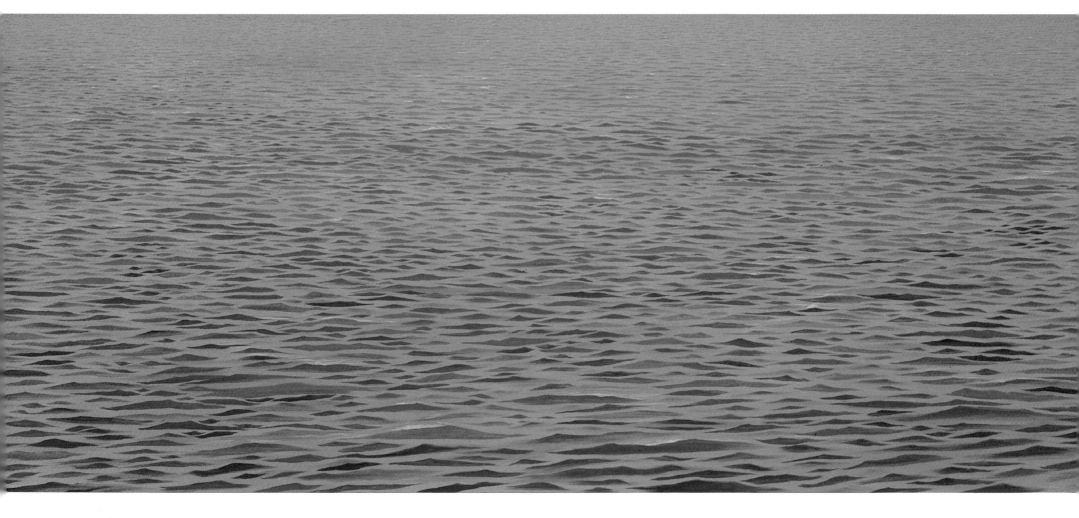

Highway I

Oil on canvas

24″ x 168″

1991-92

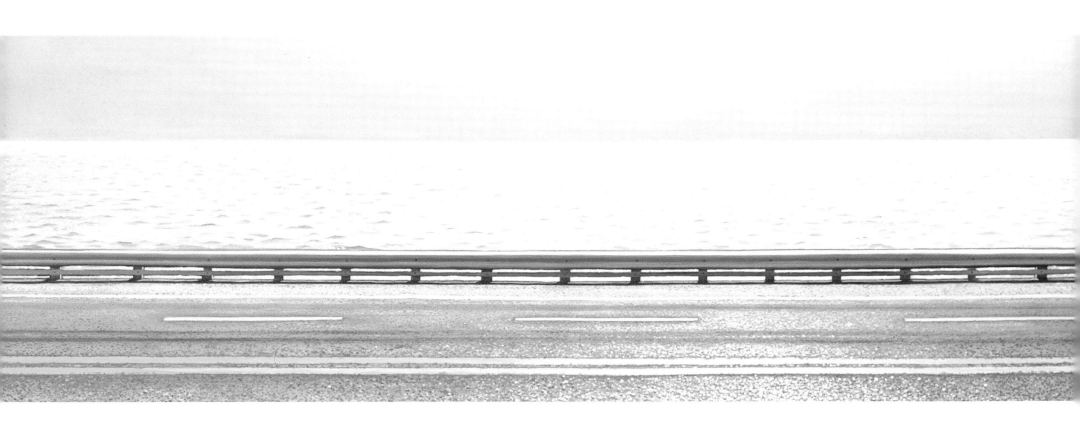

Ocean/Highway

Oil on canvas

24" x 168"

1989-91

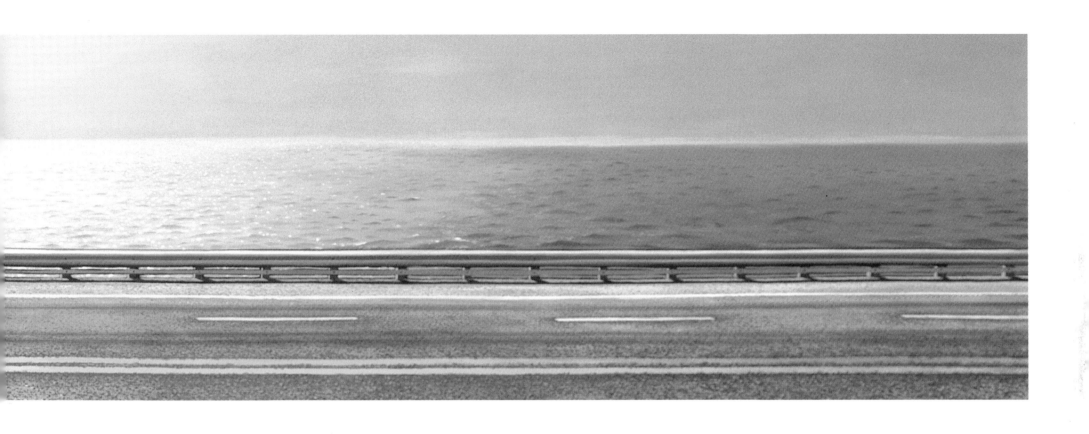

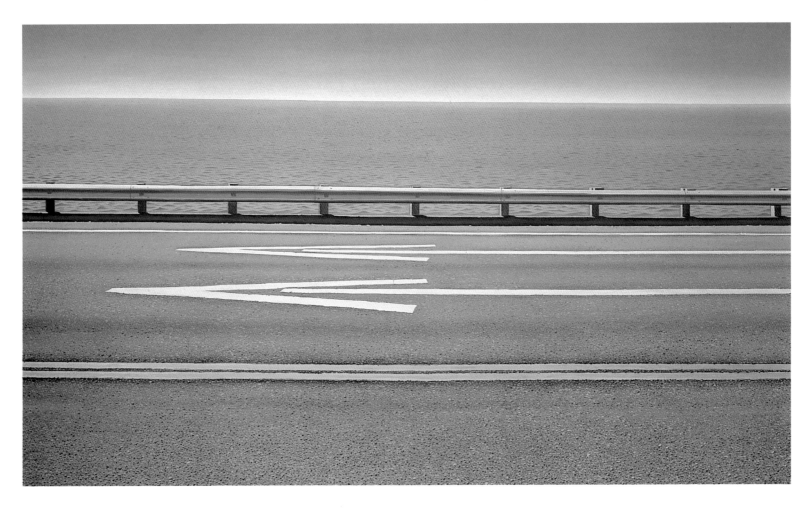

Ocean/Highway I
Oil on canvas
48″ x 96″
1984

132

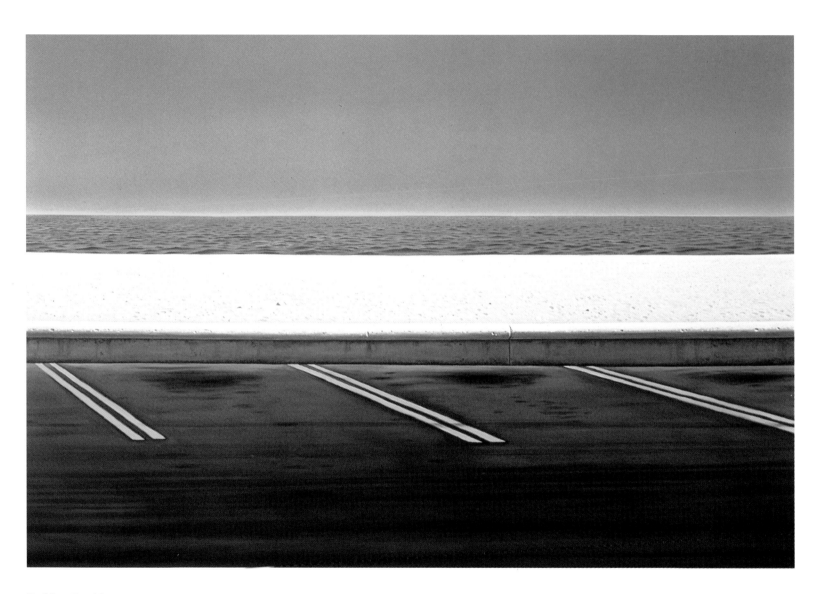

Parking Lot/Ocean

Oil on canvas

48″ x 72″

1983

133

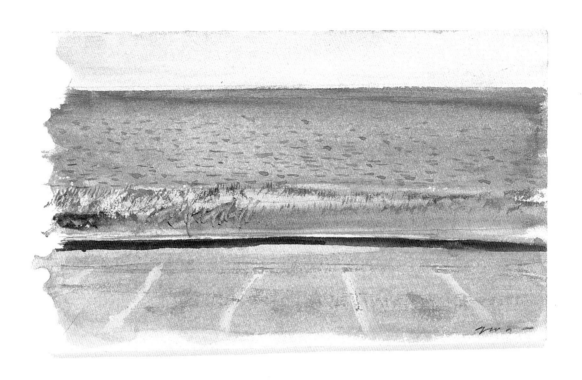

Study for Reef Point

Watercolor

3″ x 5″

1987

134

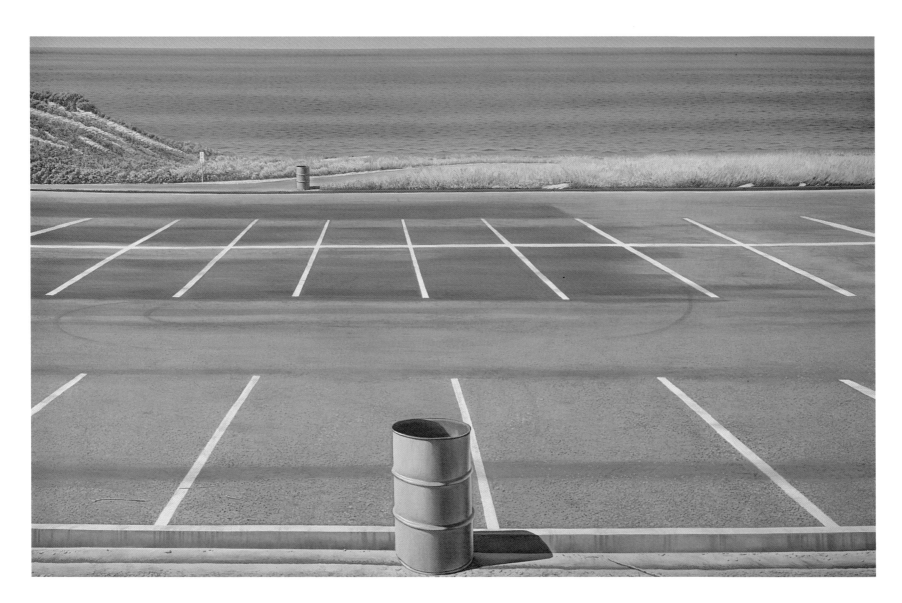

Reef Point

Oil on canvas

60" x 84"

1987

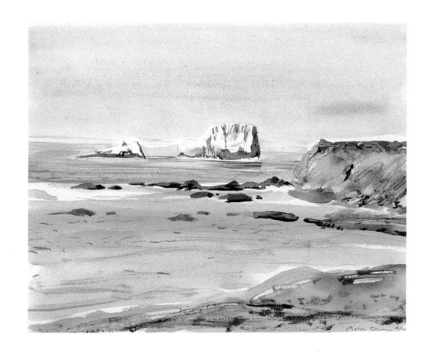

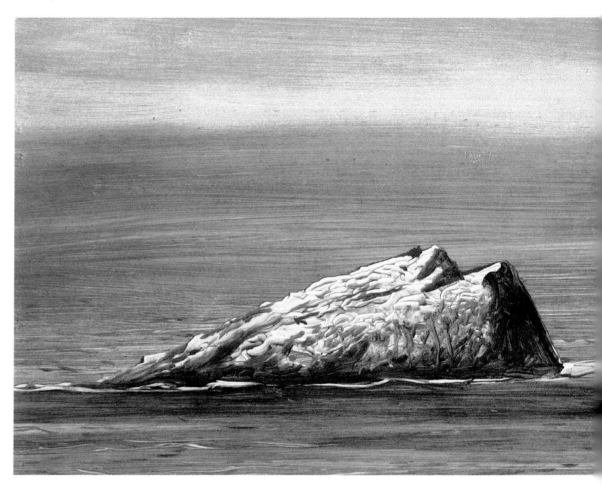

Piedras Blancas

Sketchbook

Watercolor

12″ x 16″

1990

Piedras Blancas

Monotype

8″ x 24″

1990

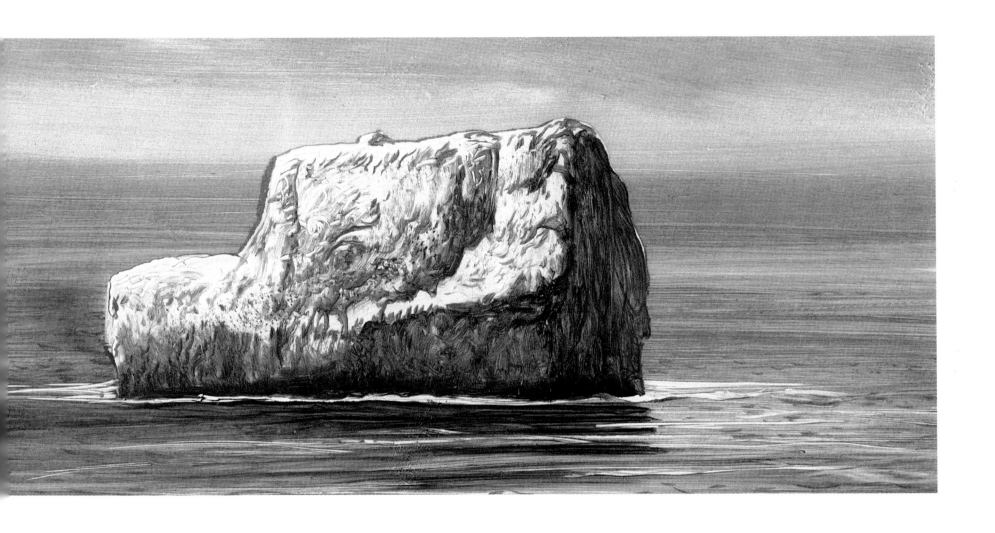

137

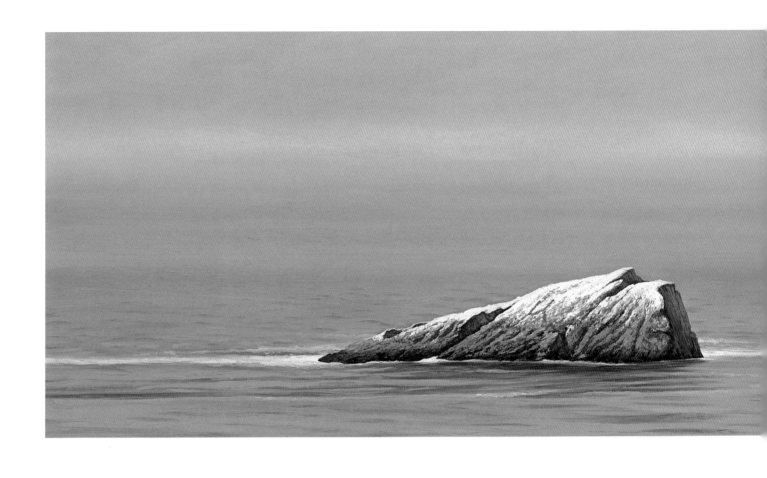

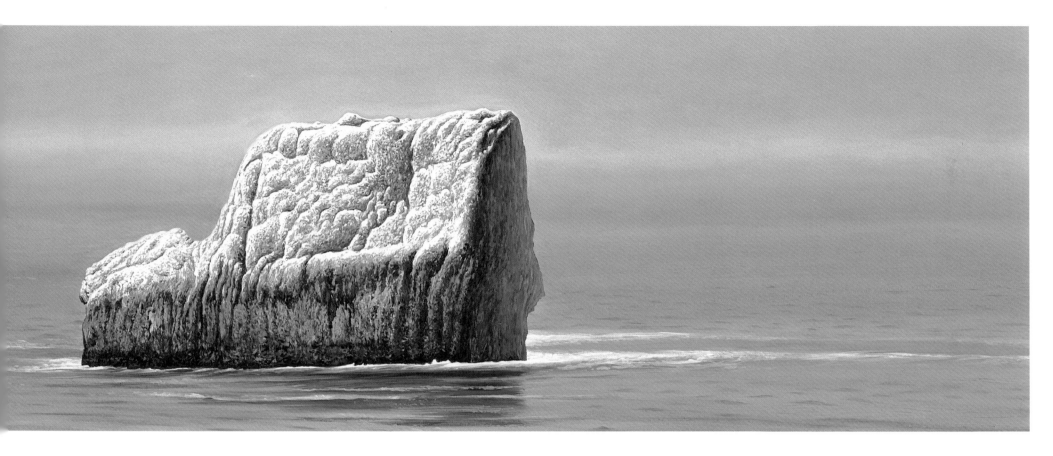

Piedras Blancas

Oil on wood panel

18″ x 78″

1990-91

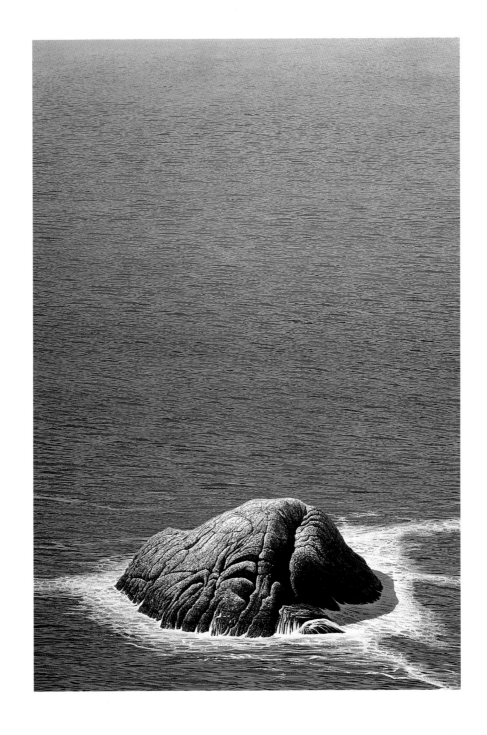

Rock and Ocean
Oil on canvas
98″ x 66″
1993-94

Trees—East of Amarillo
Oil on canvas
36″ x 36″
1984

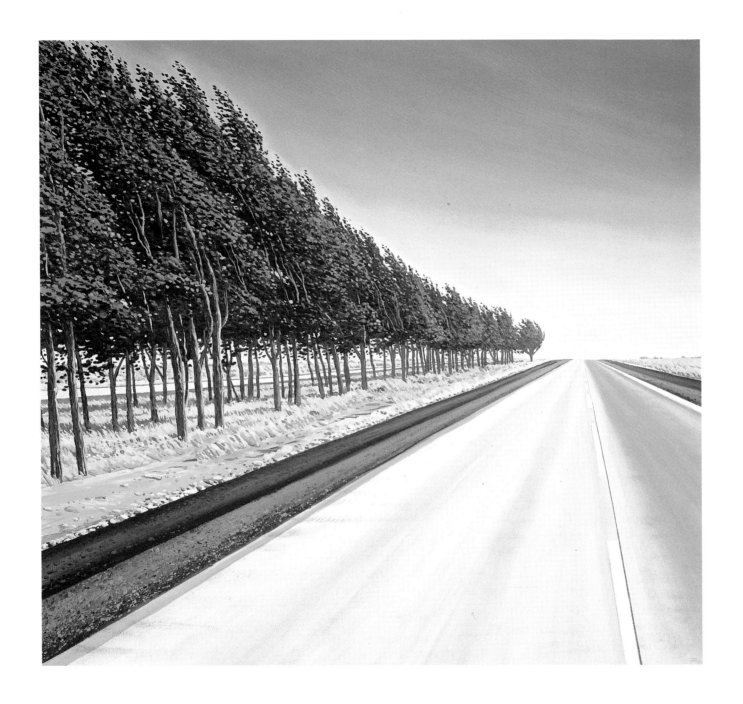

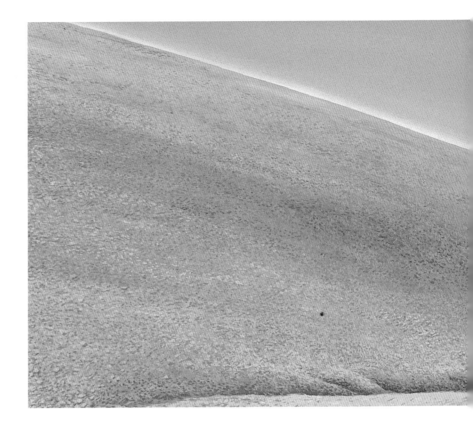

Study for Eucalyptus
Pen and ink
18″ x 12″
1990

Eucalyptus
Oil on wood panel
20″ x 80″
1992

142

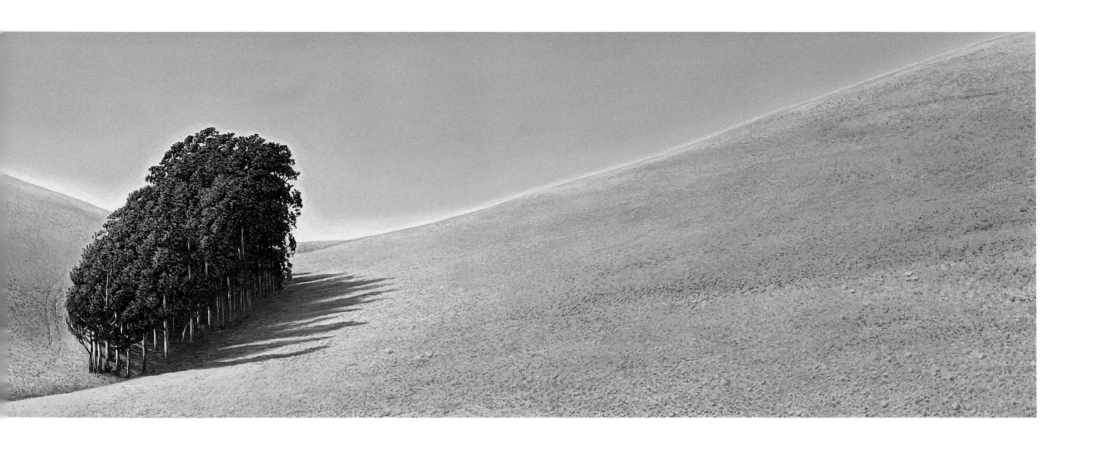

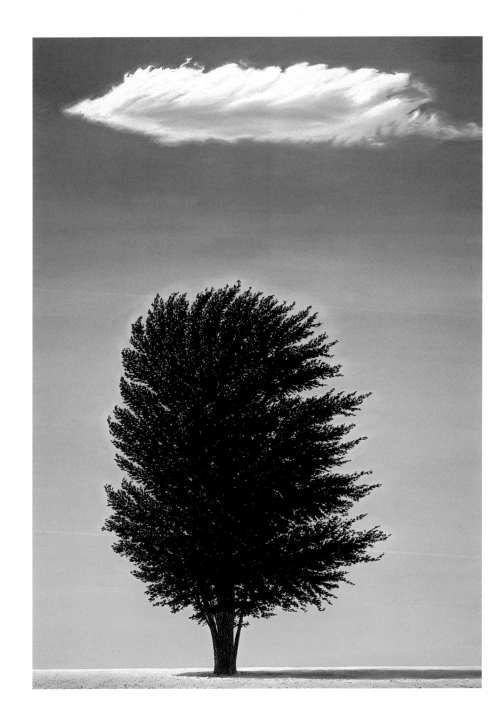

Tree and Cloud
Oil on canvas
114″ x 72″
1991-92

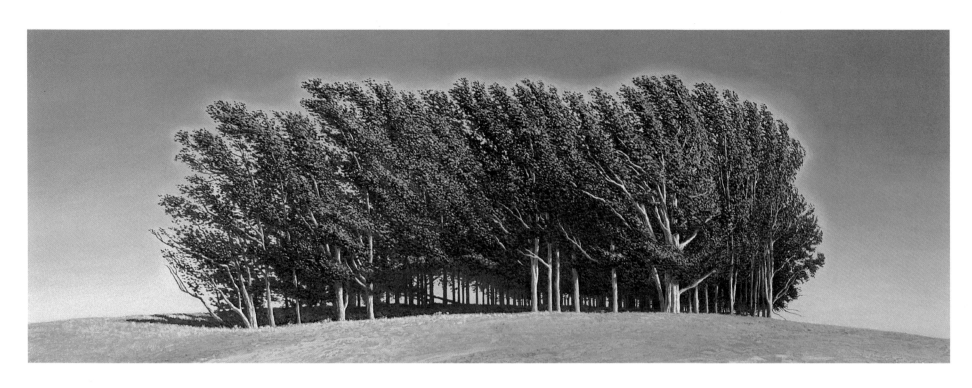

Grove

Oil on masonite

28″ x 80″

1990-91

Grove Sketchbook

Watercolor

12″ x 18″

1990

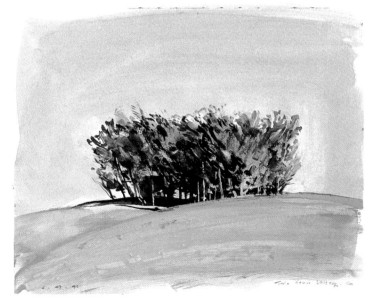

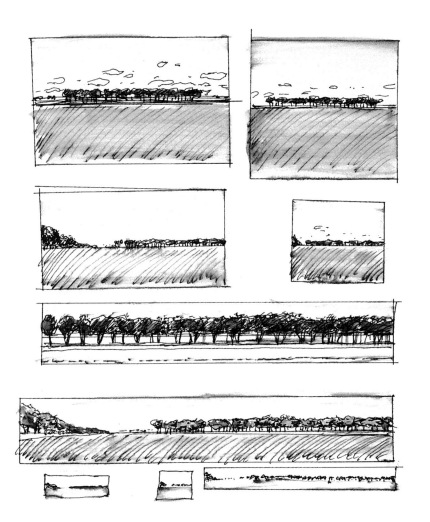

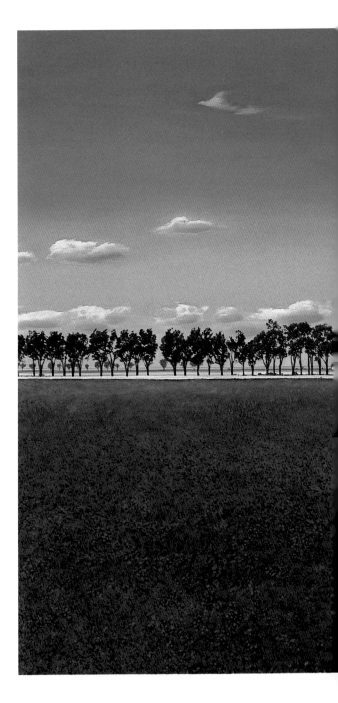

Study of Tree Lines Tree Line

Sketchbook Oil on canvas

Pen and ink 36″ x 78″

18″ x 12″ 1991-92

1981

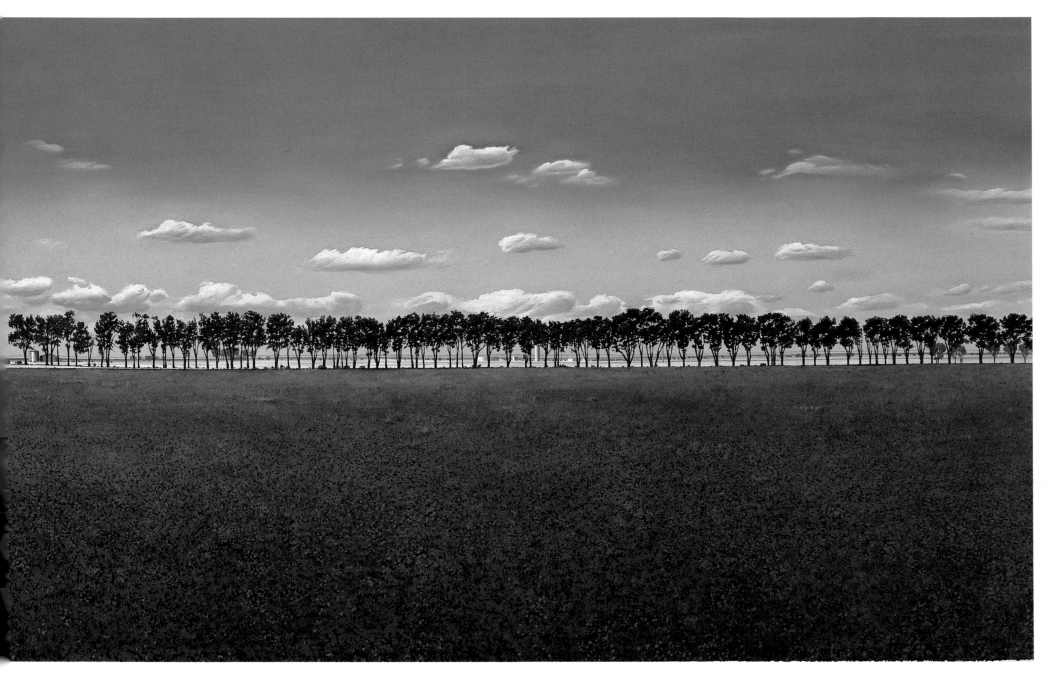

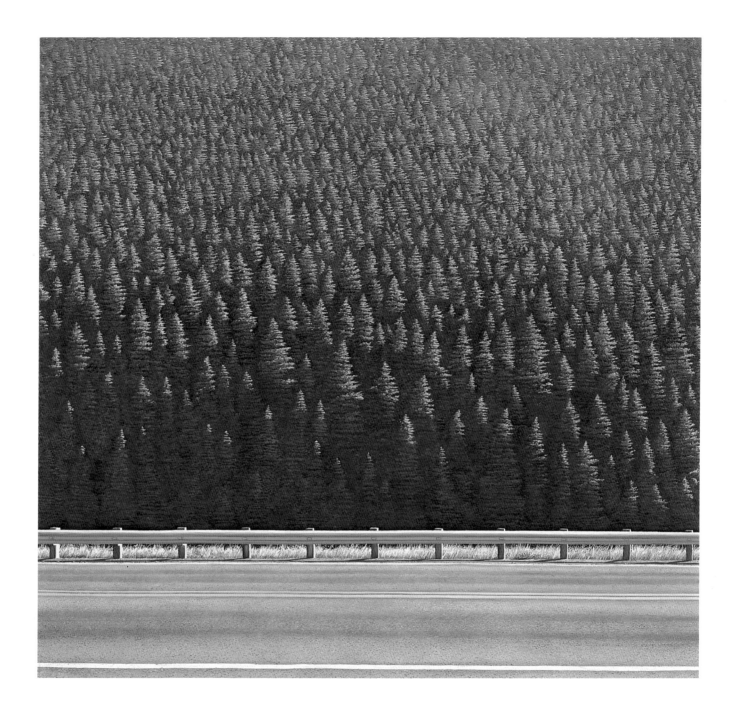

148

Pines
Oil on canvas
60″ x 64″
1993-94

Pond
Oil on canvas
69″ x 46″
1993-94

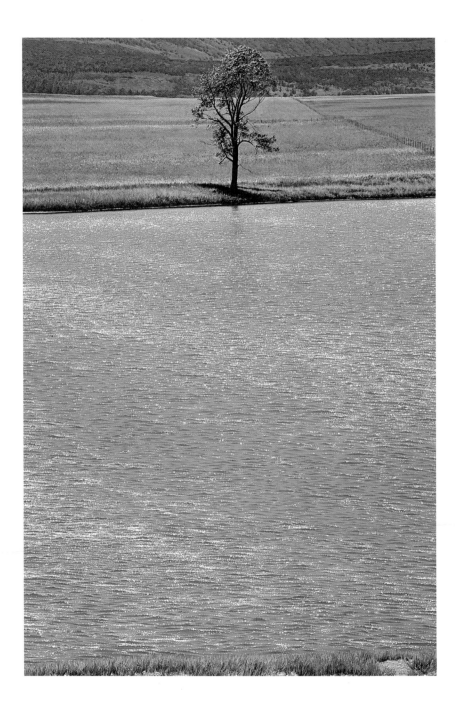

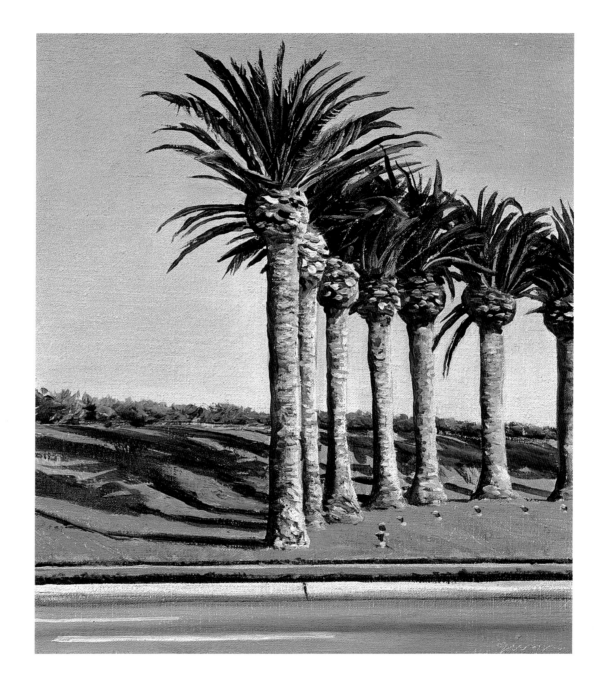

Study for Palm
Oil on linen
8″ x 8″
1987

Palm
Oil on canvas
79″ x 60″
1983

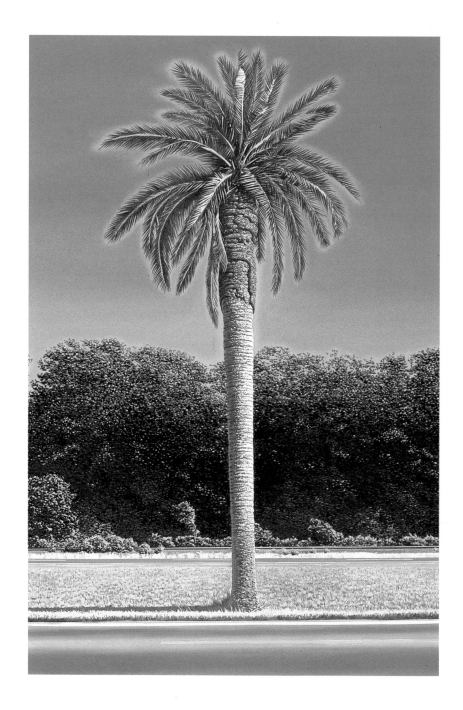

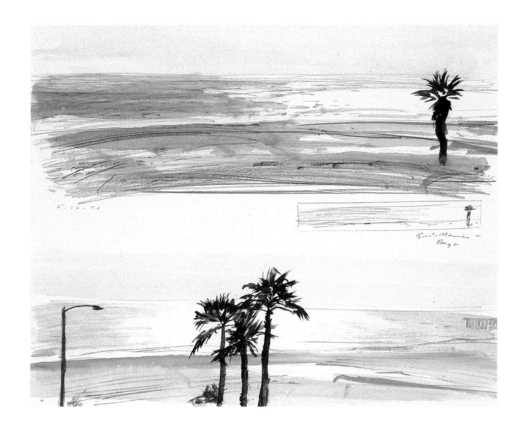

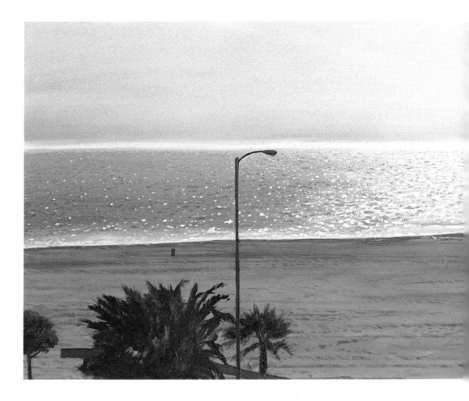

Santa Monica
Sketchbook
Pencil and
watercolor
12" x 16"
1990

Santa Monica
Oil on wood panel
18" x 80"
1990

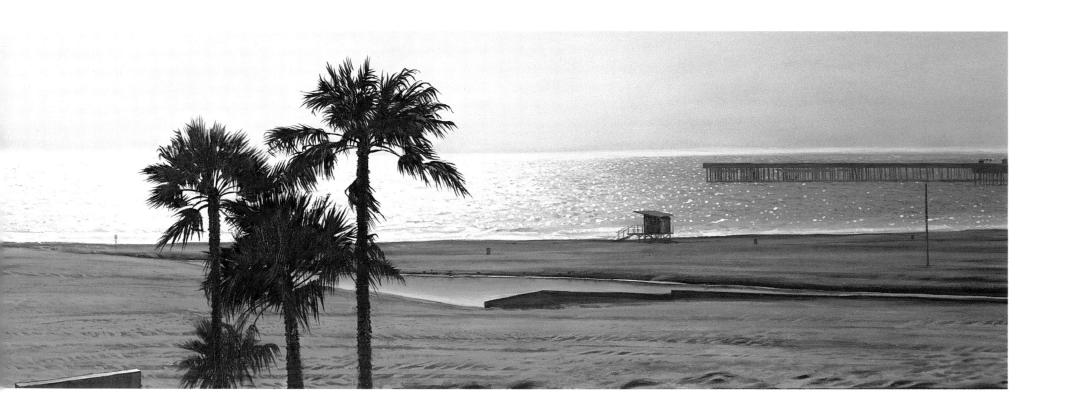

Windbreak I
Oil on canvas
72″ x 78″
1981

Tourists I
Oil on canvas
78″ x 78.25″
1991-92

FOR TICKETS, CALL: 214.747.MAVS

Monument Valley

Oil on canvas

16″ x 46″

1991-92

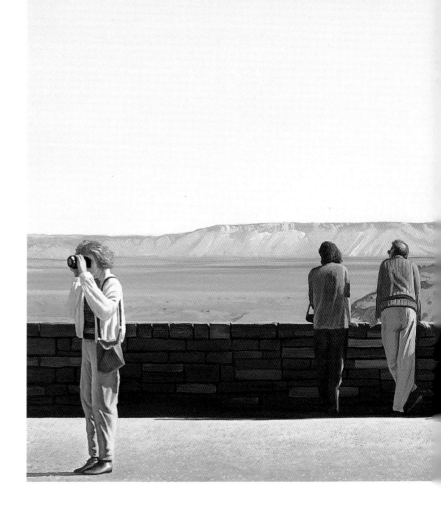

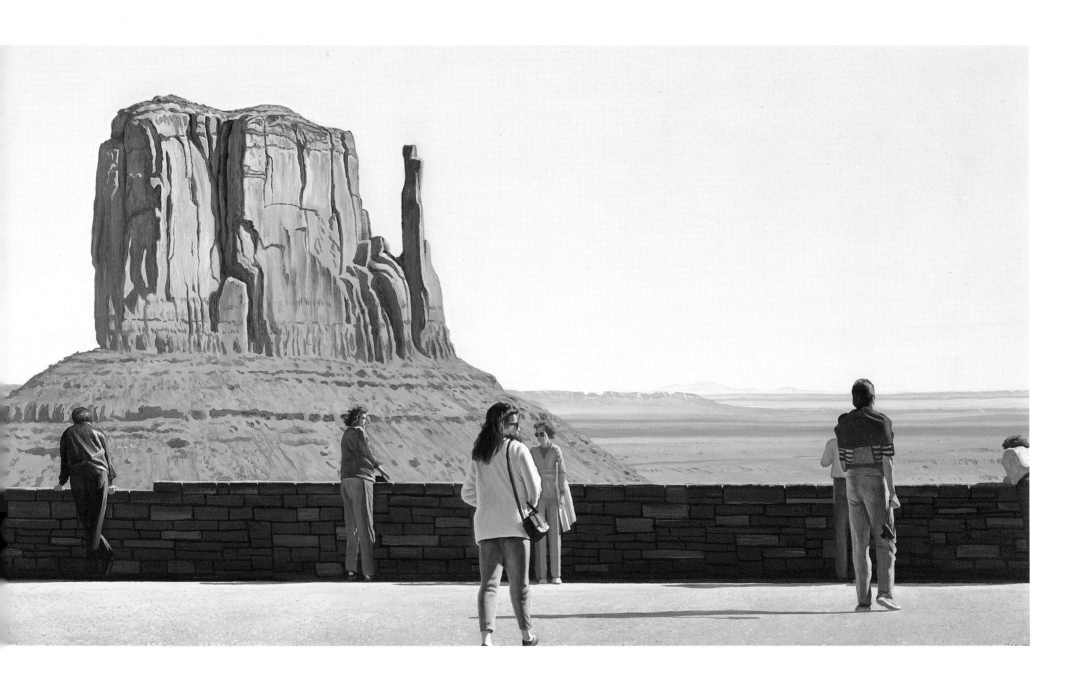

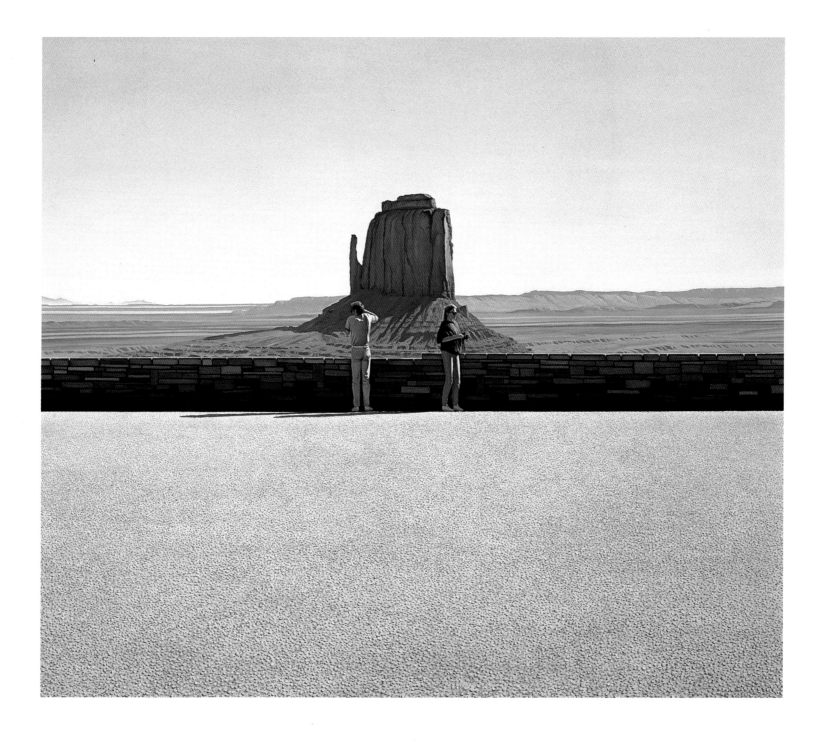

Tourists II
Oil on canvas
60″ x 70″
1991-92

Tourists
Sketchbook
Graphite and pen
and ink
Various sizes
1988

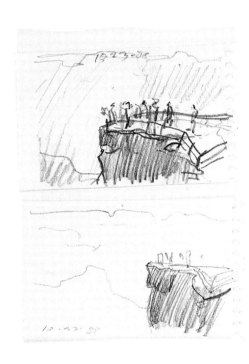

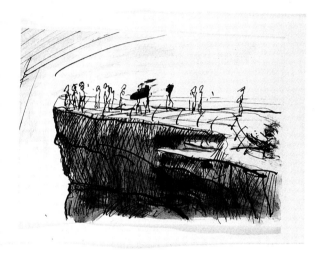

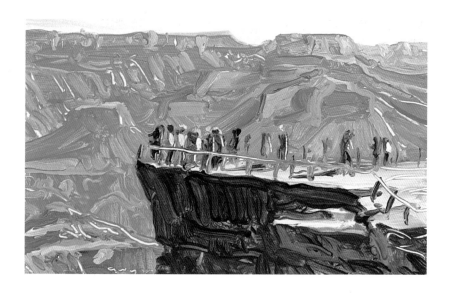

Study for Tourists
Oil on wood panel
2″ x 4.5″
1988

Tourists
Egg tempera
on wood panel
12″ x 7″
1988-89

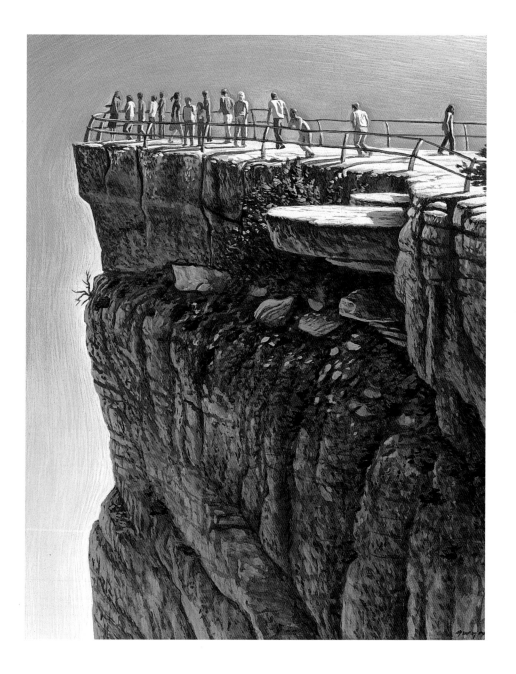

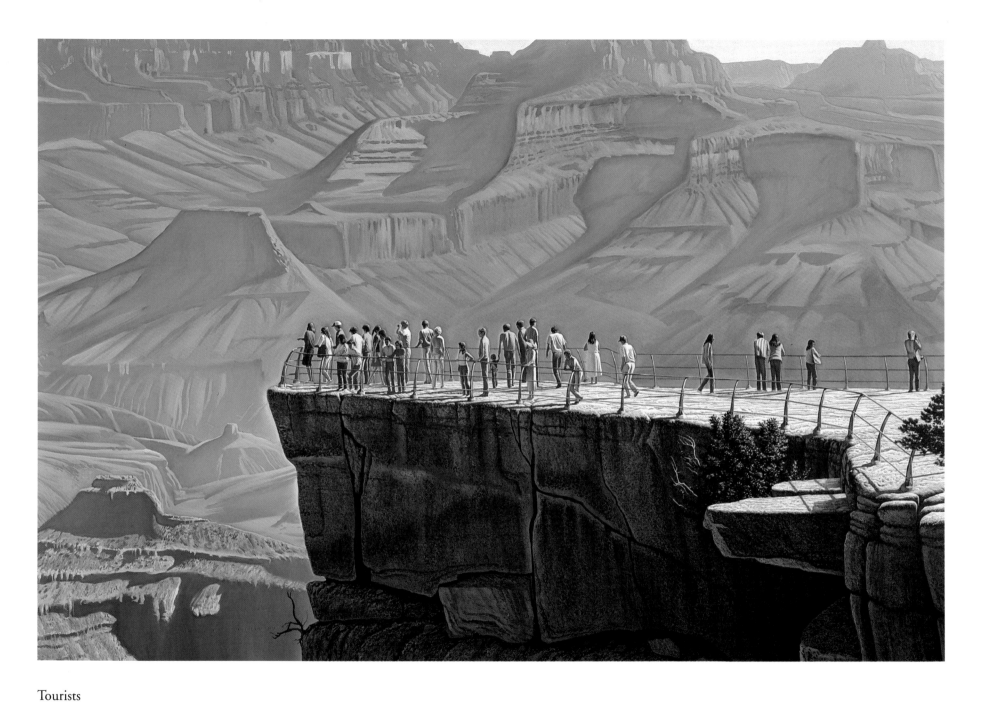

Tourists

Oil on canvas

72" x 108"

1988-89

161

AN INTERVIEW WITH THE ARTIST

MARK STEVENS

MS: *Growing up in West Texas obviously has influenced your work. What in particular do you remember about the landscape there?*

WG: The landscape is so basic and stripped down. There's just the earth and the sky. The Comanche believed that the world was created on the Great Plains and that everything else, all the other things that make up the world—the mountains, the rivers, and all the other features of the earth—went out from there. I remember Larry McMurtry said that it's such a powerful landscape that there's hardly any way to live pleasantly on it.

MS: *Do you consider the New Mexican landscape, at least around Santa Fe where you live, somewhat different from that? It has mountains—an uneven terrain.*

WG: It is different. The space in west Texas is more abstract. But there is also a tremendous sense of scale here in New Mexico because of the way the land is, and the way the weather is—the way the land is configured and the way the atmosphere is clear. You can actually see things that are seventy-five or one hundred miles away. Certain features, incidents, in the New Mexico landscape can orient you—they become metaphors for the scale.

MS: *There's a stillness to both landscapes that seems part of your work.*

WG: A stillness and a kind of void, too, much like what the Comanche were talking about.

MS: *Would it be fair to say about your work that its forms—the mountains, roads, and so forth—are used to define an emptiness rather than to fill an emptiness?*

WG: Perhaps both. I'm interested in an infinite space. Many realists are. I've heard Philip Pearlstein give talks in which he said that he thought Cézanne's work was about vast, infinite space. Rilke thought all art was a kind of infinite solitude.

One of the dangers of being a realist artist, though, is subject matter. The props sometimes become the point, instead of being a way for the artist to express his feelings and ideas.

MS: *Agnes Martin, a neighbor of yours for years, works in an entirely nonobjective style, which I know you respect.*

WG: All art, representational or not, is equally about a quality of truth. I saw an interview recently with Robert Motherwell in which he said, "What I want is the quality of the truth." It's something that can only be sensed, I think, on the intuitive level. In Agnes Martin's work there's something indefinable and ineffable going on that we can't explain in words. She probably can't either, and that's why she paints, and that's why we're interested in what she's done. You know, Rothko got very angry when people would say that his work was about color relationships and things like that. He felt his work was about the great human emotions—ecstasy, love, tragedy. I think that's what he succeeded in expressing. And we sense it when we look at the work, that something's being said to us that's true.

MS: *Martin and Rothko also share a feeling for emptiness and stripped-down forms.*

WG: Georgia O'Keeffe is another good example. Her greatest lesson to me is the importance of getting rid of everything except the absolute essentials.

MS: *Do you feel any connection to the nineteenth-century tradition of the American Sublime, specifically the Hudson River School?*

WG: Yes, I do. I think Frederick Edwin Church was certainly the greatest of the nineteenth-century American landscape painters. Unfortunately, he seems to be lumped with Albert Bierstadt. If you take the best work of Church and the best work of Bierstadt, there seems to be much more, to use a rather dangerous phrase, spiritual content in Church's work. His mind and sensibility were more highly tuned.

MS: *Church sometimes used small figures or a small house as a foil to enhance his rendering of vast scale. You mostly use roads. When did you first start with the roads? What is it about roads that attracts you?*

WG: I did my first road paintings about ten years ago, although about twenty years ago I did a series of paintings of hitchhikers. But now I consider that work too anecdotal. Anyway, about ten years ago I started the series I'm still working on. I keep thinking I'm going to do my last road painting and then I get an idea for another one. I don't know if Monet had the same experience with his lily pond. He lived almost into his eighties and painted till the very end and yet in some ways he only did, at the most, six or seven paintings. He did variations on his themes, and yet he's a great artist. The roads are available to me, like Monet's lily pond was available to him.

MS: *But it's a specific kind of road. You're not showing a little rut going off into the mountains. You are attracted to the great big, clean, supercharged western interstates. Do they help define the landscape?*

WG: Yes. They give me a way to approach the landscape. The main subject matter of my work is light and space. The roads have been a means by which I've been able to approach what I want to express about light and space. As far as the metaphorical or philosophical overtones of using a road, I have to leave that up to other people.

MS: *Do they make the paintings feel more contemporary to you? Are they partly a way to avoid being too much like the Hudson River School?*

WG: It's important for an artist to be of his time. I would think that the roads probably do have something to do with a need to feel that I'm part of my own time. But as I said, the philosophical overtones—whatever I might be saying about man's relationship to the natural world and everything—I don't really think about.

MS: *Have you ever drawn a car?*

WG: Yes. In a couple of paintings I've included automobiles and trucks but ended up taking them out, because somehow they stop the eye. I want the eye to be able to flow, to weave in and out of my paintings.

MS: *Those highly engineered roads do have a certain flowing rhythm.*

WG: They're very beautiful things in themselves. I suppose if I ever go to Egypt I might want to paint the pyramids. In some instances, roads, like the pyramids, are great examples of inspired engineering.

MS: *Let's discuss your methodology. How does a painting start for you? What's typically the germ of the idea? Are you driving along in your car and you see something?*

WG: I think that most visual artists have a hungry eye. We're always looking for something that suggests something to us. That's a phrase from Edward Hopper. He said, "I'm always looking for something that suggests something to me." I'm working now on paintings for which the germ of the idea happened two, three, four, five years ago. And what I'm always hoping for is that the idea will take on a life of its own and insist upon coming into the world. So that I become kind of a channel for it.

MS: *Once you've had that idea, do you first think about it for a long time, or do you immediately go out and begin sketching?*

WG: Well, I usually make some kind of a note about it. I have stacks of sketchbooks that have a lot of "germlike" ideas, some of which never come to fruition. Others just seem to have certain indefinable elements that urge themselves into existence. You know that phrase, *"raison d'être"?* "The reason for being" is crucial. Whenever you look at a work of art you should sense on the intuitive or visceral level that it had a reason for being, that it wasn't just the artist going into his studio or going out in the landscape and saying, "Well, this is another day, so I'm just going to do another painting."

MS: *Do you usually make a quick plein air sketch?*

WG: Well, yes, usually. Sometimes the first ones, of course, are very, very rough.

MS: *With what medium?*

WG: With whatever I have at hand. A pencil or watercolors or ink. Then I go back and maybe do some small paintings on the spot and take some photographs just for literal details. It's a matter, I think, beyond that, of listening to my intuition.

MS: *But there comes a moment when you've done, say, three or four sketches, and then you want to try a larger painting?*

WG: Yes. Another crucial aspect of the making of paintings is scale. A moment comes when I want to work on a larger scale. When I say scale, I mean the outer scale, that is, when something is fourteen feet across, you should know that it's the right scale. But the scale within the painting must also be right. That is, the relationships within the piece itself, the way the elements in the composition relate to one another, which I call the inner scale. Both the inner and the outer scale are vital to me. Vermeer's work has a lot to do with inner and outer scale. A Vermeer draws you in into a kind of intimacy. So does a Rothko. Rothko has an immense intimacy, Vermeer has an intimate immensity.

MS: *Do you project photographs?*

WG: No, I don't. I can't seem to use mechanical things. I'm a mechanical klutz. I once bought a spray gun that was impossible for me to use. Even if I could use a projection device it wouldn't be of interest to me, because I change everything around so drastically. But I certainly don't have any objections on principle. I think everything is fair in art. The only thing that matters is the end result.

MS: *Your large paintings are done entirely inside, are they not?*

WG: The really large pieces are. The sketches are so very crucial to me because they remind me of what it felt like to be out there in the midst of the reality thing. Sometimes I take photographs—but, if I don't accompany them with sketches, when I get the photographs back from the developer I don't know why I took them to begin with.

MS: *After you've decided to make a big painting in the studio, what do you do?*

WG: Then I start the inner process of really deciding what the exact scale of the thing is going to be, the size of the painting. I stretch the canvas and I usually live with it for sometimes a week or a month or maybe even more.

MS: *Do you often change your mind about both the inner and the outer scale?*

WG: Absolutely. Everything is in flux until the thing is taken as far as I can take it. It seems like there is invariably a moment when I wonder why in the world did I ever get into this to begin with. There's this moment—I don't know if other artists experience it or not, and I've been painting for years and I keep hoping that it will change, but it never does change—there's this moment when I just feel like the whole idea—it seems to happen every time, especially with the big pieces, but it even happens sometimes for a moment when I'm out working on the plein air pieces—there is this moment of total despair and defeat. Like, "Why did I ever get into this?" and, "Whatever made me think I could paint?" I remember talking to Agnes Martin about this moment that seems to happen every time, at least once, and sometimes more. And Agnes said that actually that was the critical moment in the making of art, whenever you feel totally defeated, because that's the moment when your ego gives up, and at that moment there's at least a chance for some growth and for some discovery. And as painful as it is—and it is painful—I guess there's no escaping it.

MS: *And then, if you're lucky, things click into place for you?*

WG: The only way to get past those moments is when some drastic change is made that surprises me, that makes me learn something, that makes me sense the thing in a different way than I had expected.

MS: *Would you describe that sort of change in detail?*

WG: In nearly all of the major pieces, there has been a boiling down of the composition that came as a surprise—a getting rid of some major aspect of the thing that I had thought was important to include. Or a changing of some major aspect.

MS: *Could you give an example from one particular painting?*

WG: I remember painting the highway in *Black Mesa,* a picture that's in the museum here in Santa Fe. I had done the initial sketch out on the spot, and I was true to the way the scene appeared. The asphalt had been out there for years and had sort of cured itself into a washed-out gray, and that's the way I did the initial sketch, and that's the way I got into the big painting. But the image itself, after working on it for weeks, started needing a kind of visual punch that I couldn't get into the painting if I stuck to the literal truth. I changed the asphalt, which takes up about a third of the painting, into a freshly laid tarmac of dark, almost black material, and it gave the painting what it needed. The amazing thing was that later on, a few months afterwards, I went out to Black Mesa and they had resurfaced the road and it looked just like my painting. A shocking experience.

MS: *Isn't there a very different feeling in the sketches, when you're really trying to render what's in front of you, and working in the studio on the larger paintings, where the work must be far more conceptual? There has been a tension in realism for a long time between those who are devoted to painting from life and those who order life around.*

WG: I respect people who are in both camps, and I myself do both, as you suggest. I have several painter friends who wouldn't dream of making a mark on a piece of paper or a canvas unless they were absolutely right in front of the motif,

with the subject giving them the exact information on what that stroke or paint mark is going to look like. There is an authenticity to that that can't be denied, and I certainly am after that in my plein air pieces. By the way, those are the people who tell me that I should do only the plein air pieces, and that I should hire someone else to do my big paintings. But then I think there's also an authenticity to work that's done in the studio that follows other dictates.

MS: *The dictates being?*

WG: Pictorial. The dynamism of the painting itself apart from the urge to make an absolute representation of the subject matter.

MS: *It sounds like the tension between a more conceptual or formal painting and a more realist kind of painting has been useful to you. It's always seemed to me that the desert itself has a certain conceptual quality even when realistically presented: the repetitions, the nature of the vegetation.*

WG: That's true. There's also something conceptual about the ocean.

MS: *Your most extreme paintings are the long, horizontal strips. How did you come to paint those, and why did you choose this radical shape?*

WG: With some of the long, narrow pieces it didn't matter whether or not they were seen as paintings. I've thought that they could be seen as polychrome sculptures. As I said, I feel that my main impetus as a painter is light and space. I'm trying to take it as far as I can. I'm trying to find exactly what it is that I want to paint and how I want to express it. The boiling-down process has brought me to the format you're talking about.

MS: *Those paintings look like an homage to the horizon line.*

WG: I think that's a good way of saying it.

MS: *They've stripped down space, as Giacometti strips down the human form.*

WG: I hope that's the spirit in which I'm working. For so many artists the search calls for this boiling down, this stripping down that we've been discussing. I've been thinking about Turner recently. Some of his later paintings are for all practical purposes abstract. I myself hope that someday I'll be able to paint a picture that's maybe a single tone, but a single tone that's so evocatively done it makes you feel the way you feel, let's say, when you look into an overcast sky, or into a night sky. Then I think I would be getting past the use of props.

MS: *I know how important rendering certain conditions of light is to you. Are there any qualities you keep coming back to in the rendering of light—challenges that are particularly interesting to you?*

WG: The quality of light in American painting is different from European light. And I think that, again, that's true of both realist art and abstract art. Franz Kline, for instance, has an American quality of light that couldn't have happened anywhere else.

MS: *That is that American quality?*

WG: It has more rawness to it than European light.

MS: *Are you after that, too?*

WG: I'm after the quality of truth, as I said before. That sort of raw American light is the truth I'm living, the truth I've experienced. There are times when we yearn for other things, of course. It seems to be human nature. I was reading an

interview with Antonio Lopez García recently in which he expressed a kind of yearning for another experience. He talked about how he didn't know if he'd really want to go to Italy and paint, but that maybe coming to America would be an experience he would like to try. And I've felt that in reverse. I've gone to Europe a couple of times, and I did some painting when I was over there. And so whenever I talk about the contrast between the two qualities of light, I think I know a little bit from where I speak.

MS: *Could you describe in one painting an example of an effect of light that especially appeals to you?*

WG: In my painting *14′0″*, with the landscape at the end of the tunnel, there are some qualities of light that are unusual. The tunnel enabled me to make our experience of the forms that served as obstacles for the sunlight particularly intense. The tunnel was device, if you will, to make that intensity believable. I'm always trying to find a way to paint my visual experiences as expressively as I can, and in doing that I use every device that's at hand. Whenever I'm out doing the plein air sketches, I feel a kind of desperation about how can I get this while the light is doing what it's doing, or while everything is in flux and it's changing, how can I get all of this fluidity into concrete form? I remember Agnes once saying to me, "Woody, the only important thing is that you get just some of the truth into the work. Even a little bit is enough." It's kind of a desperate enterprise.

MS: *How about the light in your ocean paintings?*

WG: I am interested in the way light can dematerialize things, which happens often with the ocean. What I'm talking about is such a powerful visual thing that there's hardly any way to describe it in painting except to imply it. And I think that some of my work is moving in that direction, toward a kind of dematerializing. Sometimes I think maybe everything is light. Maybe everything that we see around us is just compacted light.

MS: *Santa Fe is an art town, but not the main art town. Do you feel separated from the main thrust of contemporary painting? Do you feel part of the contemporary painting world?*

WG: I feel like a maverick. I remember at one of my shows at Allan Stone in New York a couple came in and I was there and they didn't know that I was the artist, and I remember one of them looking around and saying, "Well, the air must be different out there." He was right. I do live in an extraordinary environment, and that in itself affects me. But I think that the fact that I've never actively pursued the idea of, let's say, going to New York, putting my ear to the ground to find out exactly what's "going on," and then when I found out, getting into it—I think the fact that I haven't done that has in itself kept me in the maverick category.

MS: *Are there any parts of contemporary painting that you feel particularly close to? Are there other artists your age or older or younger than you whom you feel a kinship to?*

WG: There are many artists whose work I have a great deal of respect for. I would hardly know where to start.

MS: *Is there any way of connecting them, in your view?*

WG: They all have a striving to make some meaning out of the world, and I find that a very moving and exciting thing to do with a person's life.

MS: *Can you just name three or four?*

WG: Well, here in America, Wayne Thiebaud has been a hero of mine for many years. I think Antonio Lopez García is great.

MS: *What is it about his work that you like?*

WG: Antonio Lopez García seems to be an intelligent artist whose work has a very highly charged feeling for reality coupled with a tremendous feeling for the formal aspects of painting. The two together are a very powerful combination. The crucial thing for a realist is to care about the world around him that he's trying to express. I remember Whitman saying, "I love the road more than my song of the road," and that's an important thing. I think that a person trying to express reality has first got to have a strong feeling for the reality that he's expressing—and I don't just mean the props—and that if he has the technical means, like Antonio Lopez García or Lucien Freud or Avigdor Arikha, what comes across is a concern and an intense feeling for life. An artist, I think, is someone who has something to say and the technical ability to say it.

Chronology

1944 Born in San Antonio, Texas, August 22, 1944, to Estrelda and Donovan Gwyn. The youngest of three children: sister, Norma; brother, Don Nelson.

1950 Family moves to Midland, Texas. Lives for several months at grandparents' farm, where the landscape makes a strong impression.

1955 Begins classes with Arnold Leondar, an artist living in Midland during the mid-fifties. Leondar conducts weekly classes and gives slide lectures on the history of art.

1961-62 Creates a thirty-foot mural for his graduating class, a gift to Midland High School. The mural depicts a West Texas night scene with an illuminated oil derrick.

1963 Meets artist Peter Hurd, who advises him to go to the Pennsylvania Academy of the Fine Arts in Philadelphia. Attends classes at the PAFA.

1964 Returns to West Texas and begins painting Texas landscapes. Marries Nancy Burton, who has two daughters, Cheryl and Shawn Burton.

1965 First gallery exhibition at Canyon Art Gallery, Canyon, Texas.

1966 John Canaday, art critic for the *New York Times,* selects a Gwyn drawing entitled *Ladder,* to be purchased by the Norfolk Museum of Arts and Sciences (now called the Chrysler Museum). Purchases abandoned church in northern Wisconsin and uses it as a summer studio for several years.

1967 First show in Houston, at Meredith Long & Co.

1968 Moves to Hunt, Texas. Meets artist Louise Nevelson, Amarillo.

1969 Begins making regular trips to northern New Mexico. Mentioned in *Time-Life's Library of America,* 1969, "The South Central States," with a black-and-white reproduction.

1971 Exhibitions: *Mid-Western Biennial,* Joslyn Art Museum, Omaha; *Contemporary American Drawing,* Smithsonian Institution, Washington, D. C.

1972 Exhibitions: *Southwest Fine Arts Biennial,* Museum of Fine Arts, Santa Fe; one-person exhibition at Meredith Long & Co., Houston.

1973 Exhibitions: *Abstract Realism,* Marion Koogler McNay Art Institute, San Antonio; one-person exhibition at Meredith Long & Co., Houston.

1974 Included in "Realism and the Time Factor," *Southwest Art,* April 1974. Exhibitions: *12/Texas,* Contemporary Arts Museum, Houston; one-person exhibition at Meredith Long & Co., Houston. Purchases house in Los Cerrillos, New Mexico. Spends time there and in Texas. Meets numerous New Mexico artists including Georgia O'Keeffe.

1975 One-person exhibition at Meredith Long & Co., Houston.

1976 Included in "Five Southwestern Painters," review of exhibition at Davis and Long Gallery, New York, February 1976 *Arts* magazine. Exhibitions: *Twelve Contemporary Artists in New Mexico*, University of New Mexico, Albuquerque (catalog published by the University of New Mexico Press, 1976); *Looking at an Ancient Land,* Museum of Fine Arts, Santa Fe. Purchases home in Galisteo, New Mexico, and moves with family to New Mexico.

1977 Work shown in exhibition *Made in New Mexico* at Museum of Fine Arts, Santa Fe. First trip to Europe: Paris, Milan, Venice, Florence, and Rome. Stops working in acrylic and begins working in oils.

1978 One-person exhibition at Elaine Horwitch Gallery, Santa Fe. Makes trip to New York. Meets Allan Stone, who agrees to include Gwyn in a New Talent show and do a one-person show. Receives $7,000 painting fellowship grant from National Endowment for the Arts. Agnes Martin moves to Galisteo and becomes nearby neighbor.

1979 Work shown in *New Talent* exhibition at Allan Stone Gallery, New York.

1980 Included in "Six Landscape Painters," June 5, 1980 *Artspeak;* "Report from New Mexico," Summer 1980 *Art in America;* "Squaring Off in Houston," September 1980 *Southwestern Art;* "Smoke Rings-Shinto Shrines-Doktor Thrill and the Snake Lady," December 1980 *Art News.* Has first one-person exhibition at Allan Stone Gallery, New York.

1981 Included in *American Realism Since 1960,* 1981, text by Frank Goodyear, New York Graphic Society; *The Texas Hill Country,* 1981, foreword by John Palmer Leeper, color reproduction, Texas A & M Press; catalog to the exhibition, *Rosalind Constable Invites,* 1981, essay by Rosalind Constable, black-and-white reproduction, Santa Fe Festival of the Arts; "Woody Gwyn," by David Bell, November-December 1981 *Artlines,* black-and-white reproduction. Exhibitions: *Icons-Iconoclasts/New York-New Mexico,* Sarah Campbell Blaffer Gallery, University of Houston; *The Artists in the American Desert,* Sierra Nevada Museum of Art, Reno, traveling to Fresno Art Center, Fresno; Kauser Center, Oakland; Laguna Gloria Art Museum, Austin; University of Arizona Museum of Art, Tucson; Beaumont Art Center, Beaumont, Texas; Palm Springs Desert Museum, Palm Springs; Arapaho College, Littleton, Colorado; Leigh Yawkey Woodson Museum, Wausau; Salt Lake Art Center, Salt Lake City (catalog published by Sierra Nevada Museum of Art, Reno, 1981); one-person exhibition at Heydt/Bair Gallery, Santa Fe.

1982 Festival poster for *Santa Fe Festival of the Arts,* 1982, "Horizon and Cloud." Included in *Taos-Santa Fe,* catalog for the exhibition, 1982, Sheldon Memorial Art Gallery, Lincoln, Nebraska, essay by Donald Bartlett Doe; *Painting of the Land,* catalog for the exhibition, April 1982, Davis-McClain Gallery, Houston, essay by Robert McClain; "Approaching Art from Realism," *Artspeak* IV, October 14, 1982. Exhibitions: *Evolving Images* at Santa Fe Festival of the Arts, Santa Fe; *Selections from the Mel Pfaelzer Collection of Northern Illinois* at Illinois Bell, Chicago; *Paintings of the Land,* Davis-McClain Galleries, Houston; one-person exhibition at Allan Stone Gallery in New York.

1983 Included in *The West—The Modern Vision,* by Patricia Broder, New York Graphic Society; "Woody Gwyn," by Lisa Sherman, *Artspace,* Winter 1983. Review of show at Allan Stone

Gallery, "Woody Gwyn," by Michael Licht, *Arts* magazine, December 1983. Exhibitions: *Faculty Exhibition,* University Art Museum, University of California, Santa Barbara; *Santa Fe Comes to Scottsdale,* Leslie Levy Gallery, Scottsdale; *Santa Fe and Taos,* Sheldon Memorial Art Gallery, Lincoln, Nebraska, traveling to Spiva Art Center, Joplin, Missouri; Wyoming State Museum, Cheyenne; Salina Art Center, Salina; Sioux City Art Center, Sioux City; Abilene Fine Arts Museum, Abilene; one-person exhibition at Davis-McClain Galleries, Houston. Included in the Archives of American Art, Smithsonian Institution. Invited to be artist-in-residence at University of California, Santa Barbara, California. Meets photographer Hans Namuth in San Francisco. The Museum of New Mexico purchases large oil, *Black Mesa.*

1984 Exhibitions: *Art of the State,* Santa Barbara Museum of Fine Arts; *Contemporary Western Landscapes,* Museum of the Art of the American West, Houston; one-person exhibition at Modernism Gallery, San Francisco. Gives slide lecture at The Museum of New Mexico, Santa Fe, on contemporary landscape painters.

1985 Work shown in exhibition *Arts, New Mexico,* Western States Art Association, Washington, D.C., traveling to Mexico City. Painting trip to Spain during October. Executes over thirty oils on paper.

1986 One-person exhibition, *New Works by Woody Gwyn,* at Museum of the Southwest, Midland, Texas, traveling to McAllen International Museum, McAllen, Texas; the Art Center of Waco; Texas Tech University Museum, Lubbock; the Amarillo Art Center (now Amarillo Museum of Art; catalog published by the Museum of the Southwest, Midland). Has one-person show at Modernism Gallery, San Francisco. Other exhibitions: *The New*

West, Colorado Springs Fine Art Center (catalog with color photo); *Landscapes of the Southwest,* Stables Art Center, Taos; *Art of the State,* Santa Barbara Museum of Fine Arts. Meets Gregory Gillespie in Santa Fe.

1987 Included in *Santa Fe,* 1987, text and photos by Lisl Dennis and Lendt Dennis, published by Herring Press, with color reproduction. Exhibitions: *Boundless Realism,* The Rockwell Museum, Corning, New York (catalog published by the Rockwell Museum); *Landscapes from the Collection,* Albuquerque Museum of Art; *The Frederick R. Weisman Foundation of Art Traveling Exhibition,* traveling to the Israel Museum, Jerusalem; Tel Aviv Museum; Centre National Des Artes Plastiques, Paris; Pennsylvania Academy of the Fine Arts, Philadelphia; one-person exhibition at Foxley-Leach Gallery, Washington, D.C. Moves residence and studio to Santa Fe, begins work in monotype. Meets Richard Diebenkorn in Santa Fe.

1988 Articles: "Woody Gwyn," by M. J. Van Deventer in *Art Gallery International,* February 1988, with color reproductions; "Woody Gwyn," by Mark Stegmaier in *American Artist,* March 1988, with color reproductions. Exhibitions: one-person exhibition at Gerald Peters Gallery, Santa Fe, followed by review, "Woody Gwyn," by William Peterson, *Art News,* October 1988, with black-and-white reproduction; *Contemporary Painting and Sculpture,* Katharina Rich Perlow Gallery, New York; *The Face of the Land,* Southern Alleghenies Museum of Art, Loretto, Pennsylvania. Divorce from Nancy Gwyn. Painting trip, working on site, from New Mexico to Grand Canyon, Arizona, and to California coastal region from Santa Barbara to San Francisco.

1989 Included in "Southwestern Vision," by Paula Fitzgerald, in *Designer's West,* April 1989, with color photos. Has first one-person exhibition at Katharina Rich Perlow Gallery, New York. Summer painting trip to California coast, working on site from Pescadero to Bodega Bay. Purchase of building in Santa Fe with large work space and living space. Marries Dianna Koeninger, who has one daughter, Katharine Koeninger. Trip to Olana, home of Frederick Edwin Church, in Hudson, New York.

1990 Included in *Mother Road: Route 66,* 1990, by Michael Wallace, St. Martins Press, with color reproductions; "Studio Audience," by Samuel Grenguard, *Spirit,* October 1990. Exhibitions: two-person exhibition at Gerald Peters Gallery, Santa Fe; *New Art of the West,* Eiteljorg Museum Invitational, Indianapolis (catalog published by the Eiteljorg Museum, Indianapolis, with color reproductions). Receives commission from the Print Club of Cleveland, Cleveland Museum of Art, to produce etching for a forthcoming special publication. Meets Wayne Thiebaud in Santa Fe.

1991 Exhibitions: *The Eternal Landscape,* Southeastern Center for Contemporary Art, Winston-Salem; *The Hubbard Museum Invitational,* Ruidoso, New Mexico, traveling to Berlin and Moscow (catalog to the exhibition with color reproduction); *The Palm Tree Show,* Modernism Gallery, San Francisco; one-person exhibition at Katharina Rich Perlow Gallery, in New York. Spring painting trip to south-central and southwestern Colorado. Fall painting trip to Monument Valley, Utah, and to the Goosenecks of the San Juan River, Utah.

1992 Included in *Artists of 20th-Century New Mexico,* 1992, University of New Mexico Press, with color reproduction; *Printmaking in New Mexico 1880-1990,* 1992, by Clinton Adams, University of New Mexico Press, with black-and-white reproduction. Exhibitions: *7*

Artists, 7 Mediums on Paper, Katharina Rich Perlow Gallery, New York; one-person exhibition at Louis Newman Galleries, Beverly Hills; one-person exhibition at Katharina Rich Perlow Gallery, New York. Purchases 2,500-square-foot studio space in Santa Fe, which allows expansion of scale in work. Painting trip from New Mexico to California coast, working on site along coast. Extended painting trips in northern New Mexico Sangre de Cristo Mountain regions of Taos County and Mora County.

1993 Review, "Woody Gwyn at Katharina Rich Perlow," by Gerrit Henry, *Art in America,* April 1993, with color reproduction. Exhibitions: *Art and the Law,* sponsored by the West Publishing Company, Eagan, Minnesota, traveling to the Jon B. Hynes Memorial Convention Center, Boston; Kennedy Galleries, New York; Loyola Law School, Los Angeles; James R. Thompson Center, Chicago; Minnesota Museum of American Art, St. Paul (catalog published by West Publishing, Eagan, Minnesota, with color reproduction); *Daylight Fantasy . . . The Night's Dark Side*, group show at Riverside Art Museum, Riverside, California; one-person exhibition at Louis Newman Galleries, Beverly Hills. Exhibition poster, "Tourist II," published by West Publishing Company. Extended summer and fall painting trips in northern New Mexico Sangre de Cristo Mountain regions of Taos County and Mora County. Purchase Award, the West Collection, West Publishing Company.

1994 Included in *The Print Club of Cleveland 1969-1994,* catalog commemorating the seventy-fifth anniversary of the Print Club of Cleveland; half-tone reproduction. Published by the Print Club of Cleveland, 1994. Exhibitions: one-person exhibition at Katharina Rich Perlow Gallery, New York; *Realism '94,* Fletcher Gallery, Santa Fe. Spring painting trip to Canyon de Chelly, Arizona, southeastern Utah, and southwestern Colorado.

Index to the Color Plates

Publication of *Woody Gwyn* was supported generously
by the following:

Architectural Products Company Inc.,
Lindsay and Harriet Holt, El Paso, Texas;

Ervin and Norma Baumann;

and Milton Butcher.